PHOTOGRAPHING
BUILDINGS
AND CITYSCAPES

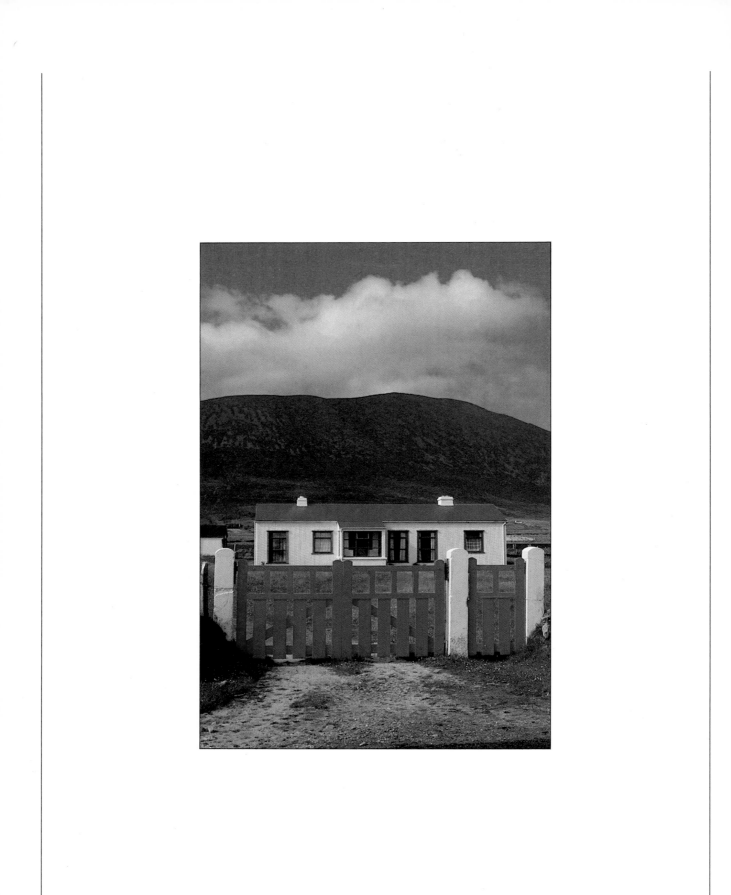

PHOTOGRAPHING BUILDINGS AND CITYSCAPES

Published by Time-Life Books in association with Kodak

PHOTOGRAPHING BUILDINGS AND CITYSCAPES

Created and designed by Mitchell Beazley International
in association with Kodak and TIME-LIFE BOOKS

Editor-in-Chief
Jack Tresidder

Series Editor
Robert Saxton

Art Editor
Mel Petersen

Editors
Louise Earwaker
Richard Platt
Carolyn Ryden

Designers
Marnie Searchwell
Stewart Moore

Picture Researchers
Veneta Bullen
Jackum Brown

Editorial Assistant
Margaret Little

Production
Peter Phillips
Jean Rigby

Consultant Photographer
Michael Freeman

Coordinating Editors for Kodak
John Fish
Kenneth Oberg
Jacalyn Salitan

Consulting Editor for Time-Life Books
Thomas Dickey

Published in the United States
and Canada by TIME-LIFE BOOKS

President
Reginald K. Brack Jr.

Editor
George Constable

Library of Congress catalog card number 82-62982
ISBN 0-86706-227-4
LSB 73 20L 10
ISBN 0-86706-229-0 (retail)

Contents

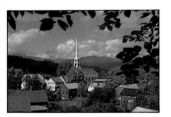
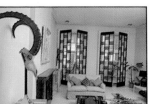

THE WORLD WE BUILD

Most people take pictures of buildings to record where they live or places they are visiting. The aim of this book is to show that photographs of houses, buildings and cityscapes can do more than just identify places. With the right camera angle and lighting, you can take pictures that bring out the beauty or character of buildings and at the same time suggest their purpose or their human associations.

Though in one way buildings are easy subjects because they are immobile and usually accessible, there are many practical challenges. Exteriors tend to be too large to fit into the viewfinder without tilting the camera and distorting the structure's vertical lines. Interiors present problems both of lighting and of framing. And town views or cityscapes can look confusing without careful composition. Techniques that will help you meet all these challenges form a major part of this book.

The pictures on the following nine pages hint at the inexhaustible diversity of subjects and show how much the impact of an image depends on the skill of the individual photographer. A quirky detail can delight the eye as much as a panorama of massed buildings with all their colors, textures and sweeping lines of perspective. And a wooden cottage can speak to us as tellingly as the emphatic grandeur of a monument such as the one opposite.

A wedge of light on the steps of the Jefferson Memorial, Washington D.C., leads the eye firmly to the shadowed columns and stresses the classical precision of the architecture. The photographer waited for late afternoon sun and used a polarizing filter to intensify the blue sky. A 24mm lens sharply recorded the fine texture of the marble steps and emphasized the building's mass.

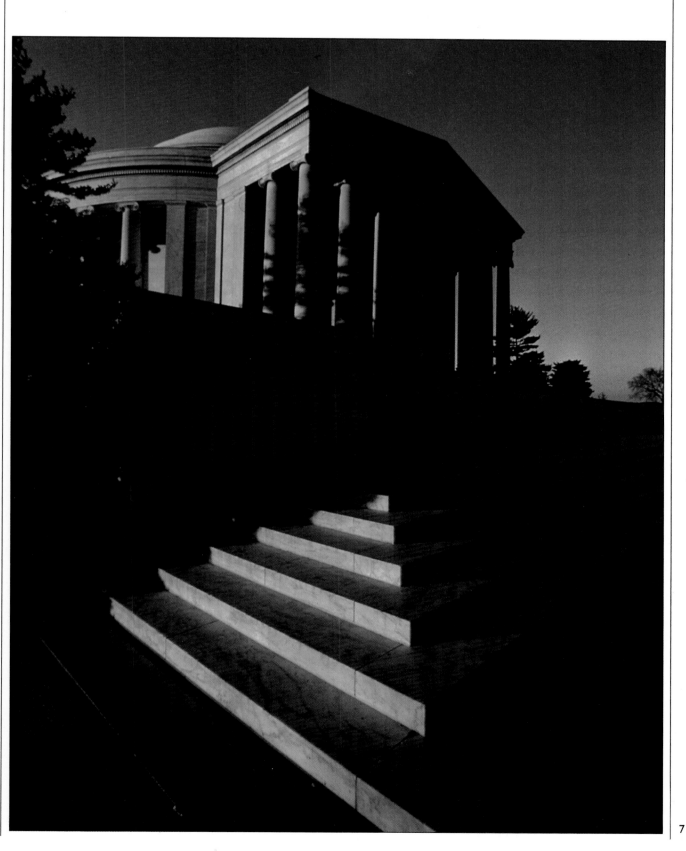

Snow-dusted roofs in suburban London acquire the soft beauty of a pastel sketch. The picture shows how scenes that might appear dull under some conditions can come alive with a change of light and weather. The snow made possible a near-monochrome effect with just touches of restrained color.

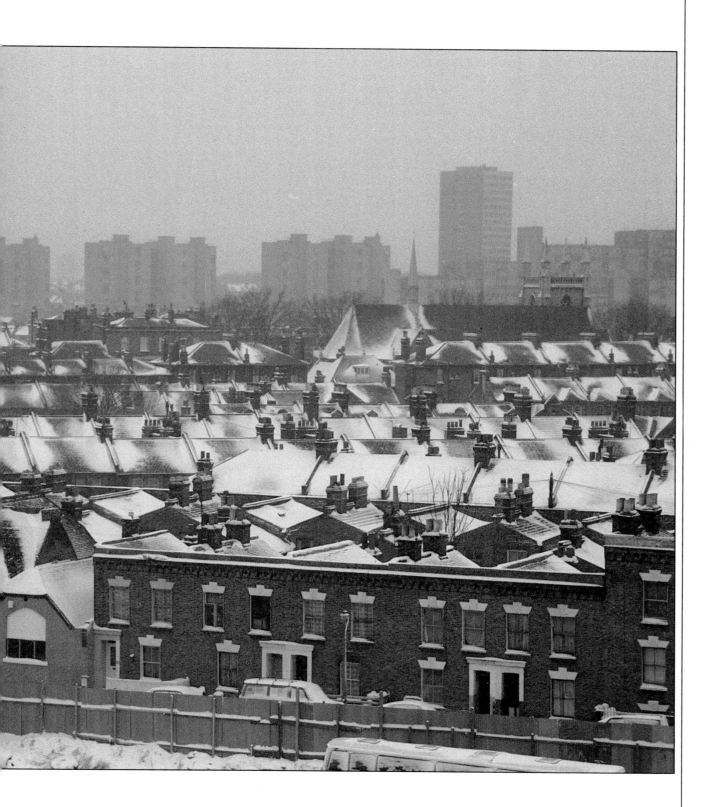

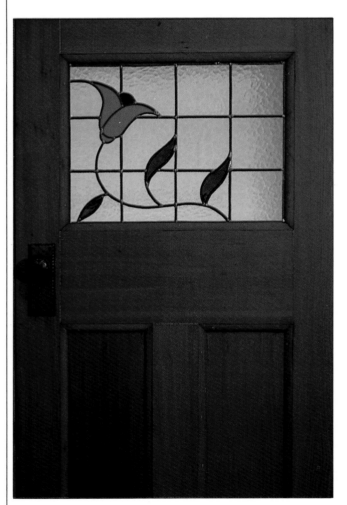

A stained-glass window in a connecting door between rooms shows how a simple detail can delight the eye. Close framing contrasts the sinuous flower stem against the squares of lead, the dimpled glass against the grainy wood. Daylight film used in tungsten light from two household lightbulbs produced an orange cast that harmonizes with the petals.

Brick and stone facades in Seattle, Washington, slant toward a modern skyscraper in a glorious diversity of stone textures and colors. The photographer used a 400mm lens from a window on the other side of the street to cram the buildings together and emphasize the verticals.

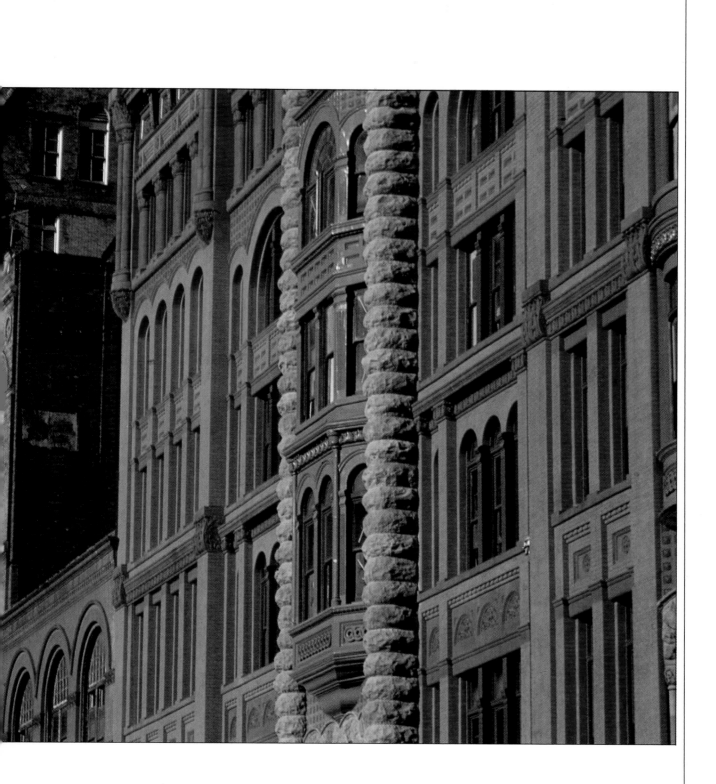

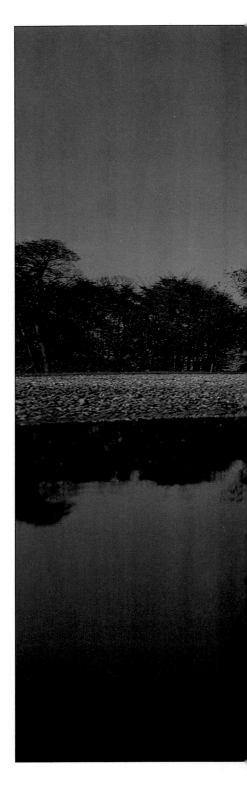

An exuberant jumble
*of black and white, Little
Moreton Hall in Cheshire,
England, is one of the finest
examples of Elizabethan
timbered architecture. To
heighten the impression of
a structural puzzle, the
photographer moved to the
far side of the lake for a
mirror image. The historic
home attracts many visitors,
and so he waited patiently
for a lull in the flow to
avoid distracting attention
from the building itself.*

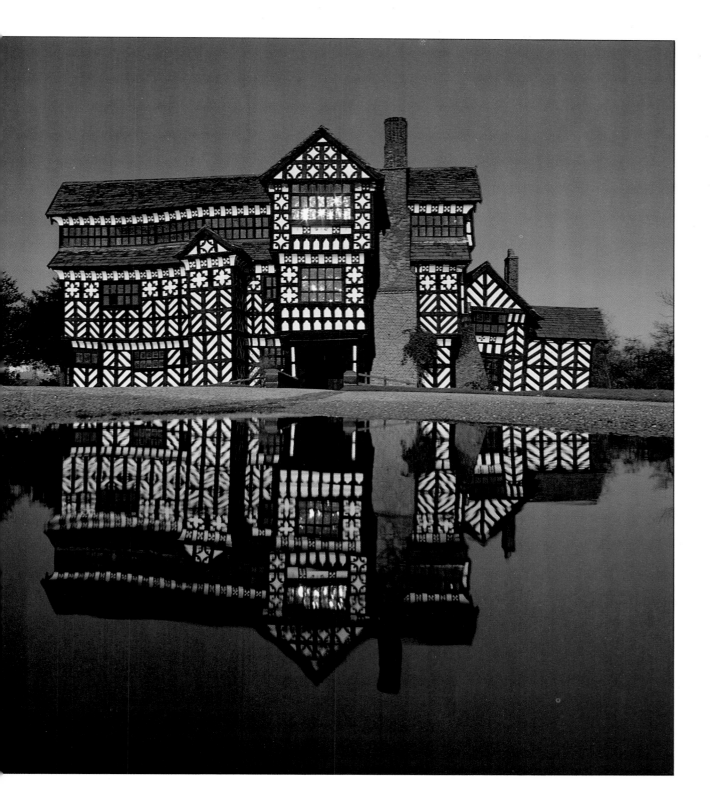

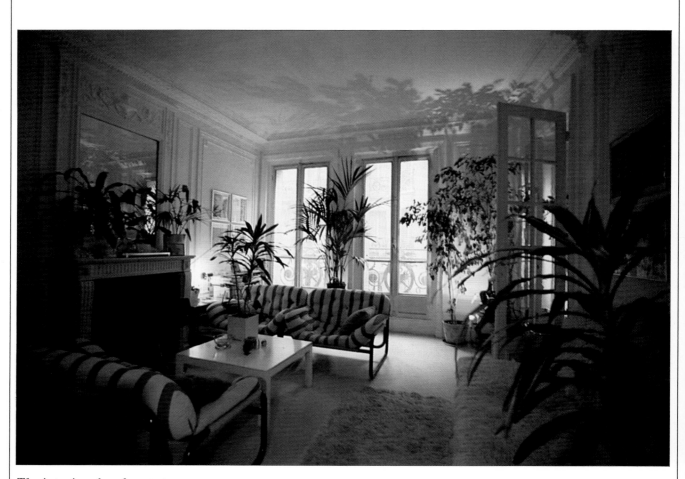

The interior of an elegant apartment
needed skillful lighting to record the
soft plant shadows cast by two household
spotlights. To reduce contrast levels,
the photographer put a strong photolamp
beside the camera and covered it with a
No. 80B blue filter so it would match
the daylight entering the room.

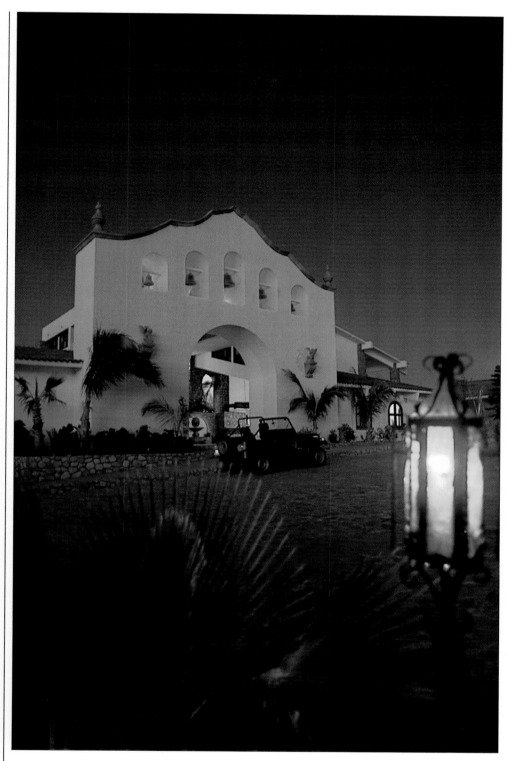

A hotel in Cabo San Lucas, Mexico, glows with lights warmed in color by the use of daylight film. The timing of the picture at dusk, the inclusion of the foreground plant and the choice of a low viewpoint combine to evoke a mood of theatricality appropriate to the character of the architecture.

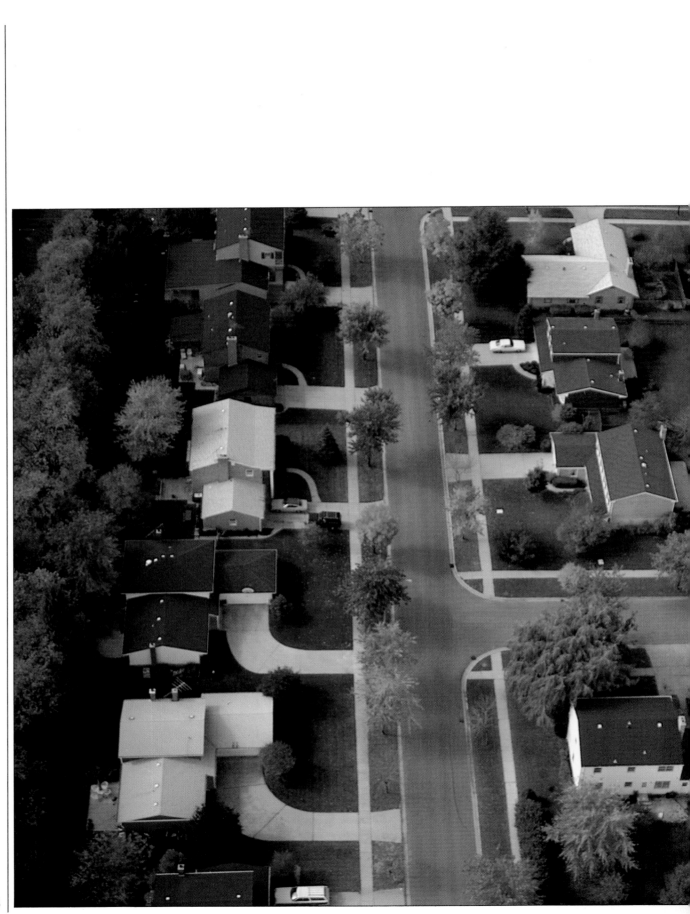

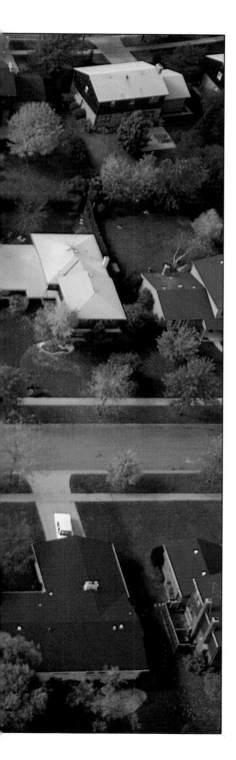

THE SEARCHING EYE

To make your photographs more than a bland architectural record demands some skill and imagination. One point to keep constantly in mind is the human element. Buildings are designed by and for people, and this, much more than the physical details of their construction, is what gives them their character and variety. Try to look beyond the obvious structure of a building and to consider why and how it came to be there. For example, the clustered dwellings of an isolated fishing hamlet suggest simplicity of lifestyle and a common purpose. By contrast, affluent suburban villas may reflect the value placed on privacy from neighbors.

Once you identify what is uniquely interesting about a building or settlement, this will help you decide on an apt visual treatment. In the picture at left, the photographer chose an aerial view to reveal the ordered plan of a suburban block – a plan that extends from the houses themselves to the landscaped plots on which they stand. The following section explains how lighting, framing or viewpoint can accentuate such chosen features and bring out the character or the intricate history of a subject.

Neat rectangles of lawn delineated by paved walks, curving driveways and shrub borders separate the houses in a prosperous suburb of Chicago. The formal plan of the neighborhood has been exaggerated by an overhead viewpoint.

Viewpoint

The most important question in photographing architecture comes before you even pick up the camera – what viewpoint to choose.. If you want to take an undistorted, descriptive picture of the subject, the only way to do so is to explore all the possible viewpoints. Walk around the building you plan to photograph and scan the surroundings for vantage points such as tall buildings or hillsides that overlook the site. Having identified some likely camera positions, you will need to visit each one to ensure that it is accessible and affords the sort of composition you are looking for. For buildings such as cathedrals, do not rule out very distant view-points. With clear weather and a long telephoto lens, you can photograph a large building from a mile away.

If you are seeking a more subjective view or making a series of pictures of the same subject from different angles, as at right, you may wish to choose several viewpoints very close to the building. Although this will produce distortions, such pictures do show buildings as they might appear to pedestrians craning their necks upward. Sometimes, a stretched, converging view such as the one below can give a far more vivid impression than can a measured, precise picture taken from a distance.

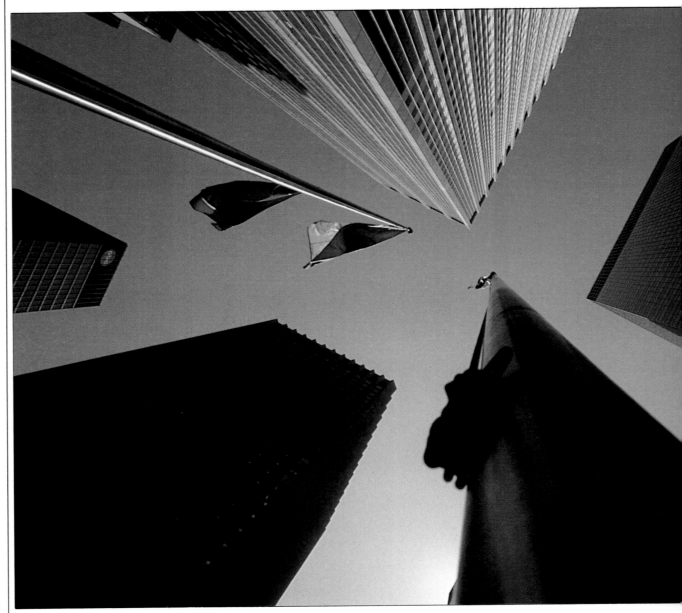

Steel and glass towers *(below) dominate this geometric view on Park Avenue in Manhattan. To add yet another converging line to the image, the photographer – who used a 20 mm lens – positioned his camera against a flagpole.*

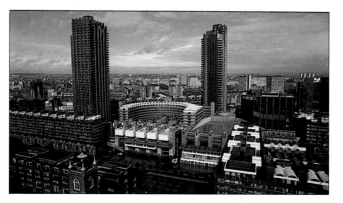

Changing viewpoints *or lenses in the sequence at left revealed strikingly different aspects of London's Barbican complex. The first picture, taken with a 24 mm lens from the top floor of a neighboring office building, gives a general impression of the scope and scale of the site.*

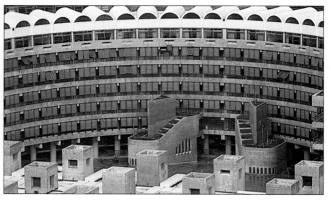

From the same position *as above, but switching to a 105 mm lens, the photographer singled out just one element of the center, drawing attention to its curving facade and the rhythm of windows and arches.*

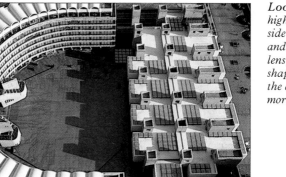

Looking down *from the high-rise building at one side of the curved facade and still using the 105 mm lens, the full horseshoe shape becomes clear, and the elegant vaulted roof more prominent.*

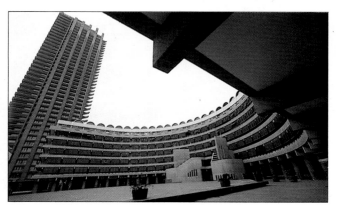

Looking back up *at the tower from the cloistered courtyard, the photographer used a 15 mm lens, which makes the building seem to taper. Yet the picture gives a vivid sense of what it feels like to walk around the complex.*

The right light

The changing qualities of daylight can radically alter the appearance and mood of buildings. For example, in the photograph below, the white walls of the San Xavier Delbac Mission in Tucson acquire an unearthly luster as a storm approaches – an effect that neither a clear nor a dull day could produce.

While this kind of light is excellent for heightening colors, different light conditions may suit other architectural qualities. When the overall shape of a building is important or when there are subtle variations of texture and color, an overcast day often shows these elements better than a sunny one would. Soft, uniform, misty light can create atmosphere, as in the picture at right. Direct sunlight, on the other hand, produces strong contrasts that emphasize geometric patterns or throw details of carved stone and wood into strong relief.

If you decide to take pictures in sunlight, choose the time carefully. You can use the low light at the beginning and end of the day to create long, raking shadows or to take advantage of golden reflections on windows. But in cities, early and late sun may catch just the tops of buildings, and penetrate only streets that run east-west. Thus, in urban areas, you may need to take pictures when the sun is higher.

If you have time, try to return to a location at different times of the day. This way you can make a fascinating record of the changing character of buildings as the sun moves across the sky and the light changes, as on the opposite page at bottom.

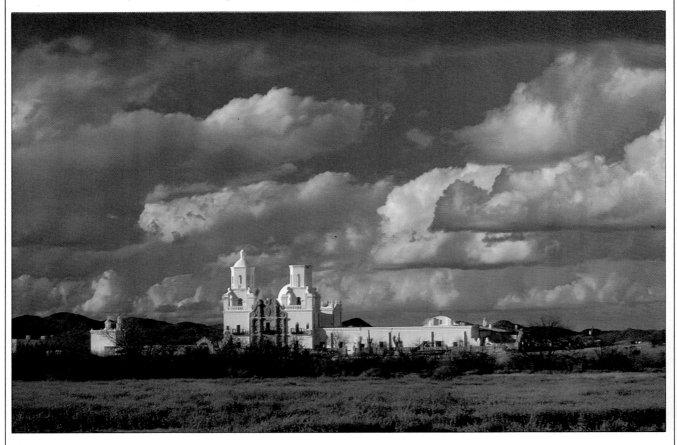

A whitewashed Arizona mission glows white in dramatic stormlight. To emphasize the brilliance of the mission's sunlit walls, the photographer set her camera's ISO dial to double the speed of the slide film she was using, underexposing the picture by one stop.

The rooftops of East London
loom through the mist on an overcast day. By reaching out to the paler tones of the more distant buildings, a 200mm lens helped to separate the receding planes of this simple, monochromatic scene.

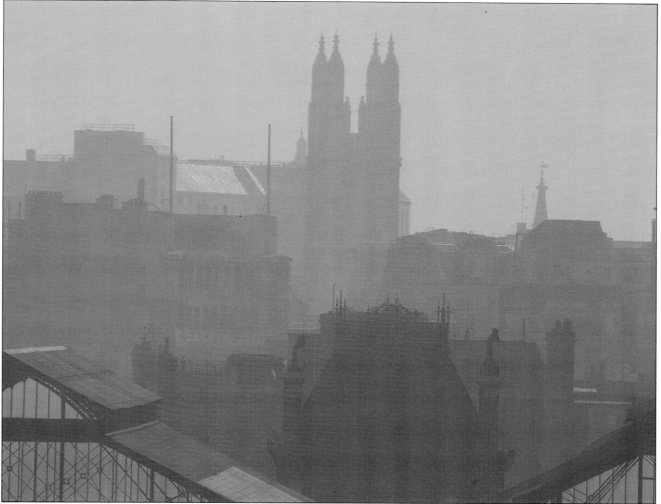

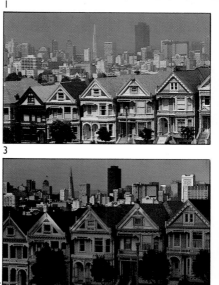

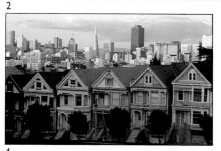

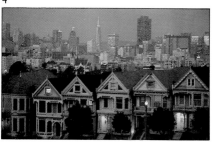

A San Francisco skyline *(left) shows different facets and colors from almost the same viewpoint in the space of a few hours. At midafternoon (1), the high sun picks out every detail of the ornate wooden houses in Alamo Square but flattens the overall city scene. Toward evening (2), the shadowed houses and sunlit taller buildings give a greater impression of distance and of modern architectural forms. At sunset (3) the weakening rays of the sun reduce the contrast. Twilight (4) gives the most striking picture of all as the city's twinkling lights begin to supplement the daylight. For this picture, the photographer made a series of exposures to ensure that he obtained an ideal balance in the rapidly changing light.*

Scale and context

Few buildings exist in isolation. Although your first impulse may be to exclude the surroundings, always consider whether a view of the building in its setting will make a more arresting picture, or whether you need to add an element to suggest scale.

Many buildings on a grand scale were designed to be seen in the context of the more modest structures surrounding them. The cathedral towns of Europe are good examples. But even in a modern city that has grown up without any overall plan, the relationship between buildings can make interesting compositions, revealing contrasts in character and scale. For example, in the view of San Francisco at right, juxtaposing the concrete giants dominating the horizon with the lower level buildings in the foreground provides a contrast between old and new and also conveys the tremendous height of the skyscrapers beyond.

Another good way to suggest scale is to include a small element that gives an immediate clue to the size of a building. Human figures are particularly effective, because we naturally judge the scale of things in terms of our own size. In classical architecture, entrances and windows are often on a massive scale. You can convey this dramatically by framing to include a distant figure, as in the picture below.

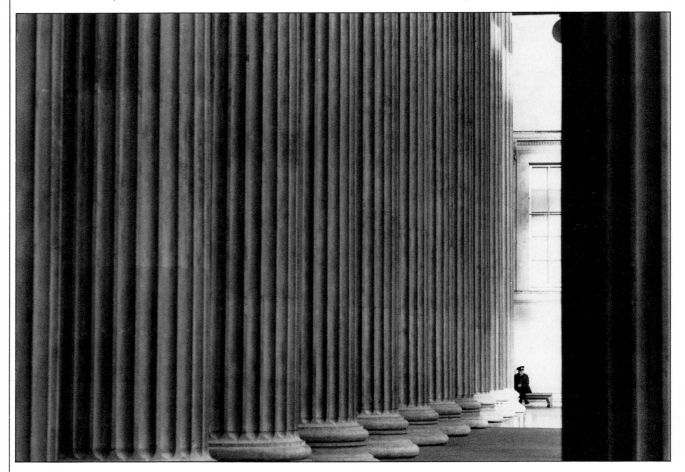

Majestic fluted columns
at the entrance of the British
Museum in London overwhelm
the tiny figure of a seated
attendant. The sharp contrast
in scale is exaggerated by the
sense of depth created by the
receding columns.

Office high-rises (right)
loom above older residential
buildings in San Francisco
and are dwarfed in turn by
the Trans America Tower's
giant concrete spire. A high
vantage point made the smaller
buildings appear even lower.

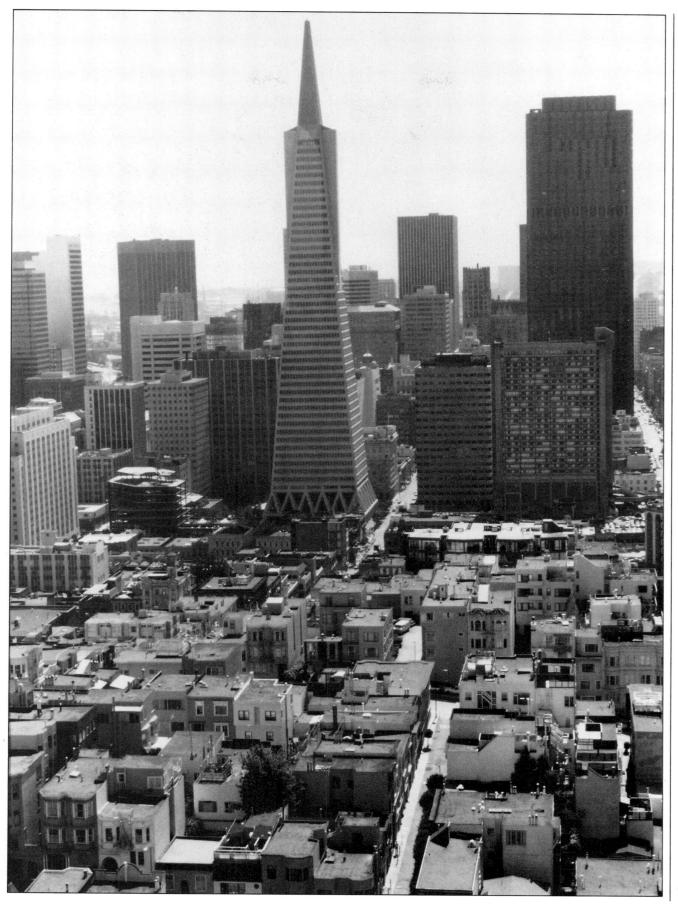

Frames

By its very nature, architecture is rich in frames that can be used in photography to indicate depth or to obscure unwanted details and create a dynamic composition. With your camera set to a small aperture for good depth of field, you will find plenty of effective uses for doorways, windows, arches and other types of openings as borders for subjects that are themselves architectural. Look for unusual shapes, such as the rosette that frames a view of Florence in the photograph below. If a ready-made frame is not available, you can often create your own by a judicious choice of camera angle, as in the scene of Tokyo skyscrapers, opposite at far right.

To concentrate interest on the main subject, try to find a frame that is not distractingly detailed.

Alternatively, leave the frame in shadow and base the exposure on the subject beyond as demonstrated in the Tokyo view here.

Natural features such as trees or foliage, whether sharp or deliberately unfocused, make attractive frames for buildings in rural or garden settings. In the picture of a château outside Paris, at near right, the line of trees with their leafy canopy contributes a touch of irregularity that nicely offsets the formal gardens nearer the house.

An inventively framed picture is always satisfying, especially if it contains elements of wit or novelty – qualities both subtly present in the photograph opposite below, which uses an entire farm building as the frame for a perfect silhouette of a cow.

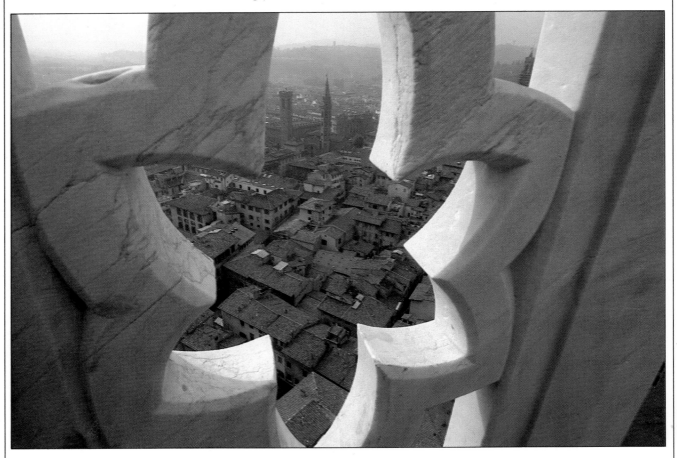

The tiled roofs of Florence are here set like a townscape jewel within the elegant marble setting of a floral tracery motif high on Giotto's belltower. The grainy white marble surface makes a pleasant contrast with the texture of the roofs. A 28mm wide-angle lens and a small aperture setting gave good depth of field.

The Château Vaux-le-Vicomte
and its formal garden contrast with
a foreground frame of silhouetted lime
trees flanking an avenue. The depth of
the picture emphasizes the grandeur of
the house, once set in a vast estate.

Soaring freeways frame a glimpse
of Tokyo and give the picture movement.
The photographer exposed for the
skyscrapers after checking that this
would underexpose the bridges by two
stops and leave them as deep shadows.

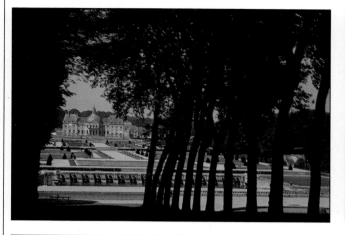

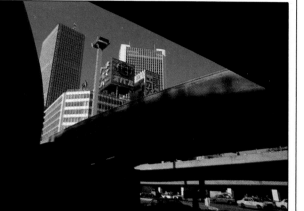

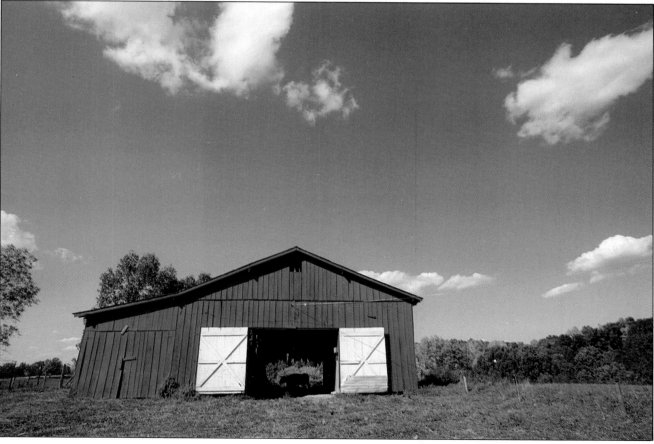

A Kentucky barn opens its doors
to the summer heat. The massive white
doors help to draw attention to the
drying tobacco plants within, which
in turn frame a solitary animal
enjoying the shade. By placing the
building beneath an expanse of sky,
the photographer gave it a powerful
sense of weight and presence.

Silhouetting for shape

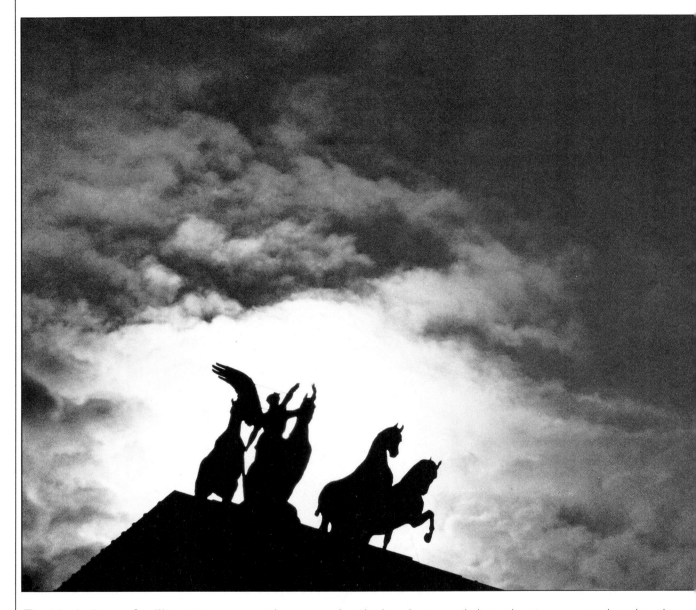

The blank shape of a silhouette can sometimes reveal more about the structure and character of a building than a brilliantly clear, frontlit view. With the light behind the subject, cornices, guttering, architectural ornament and other details disappear in shadow, so that the building's outline dominates the picture.

At its simplest, making a silhouette is just a matter of framing the subject against the sky and underexposing the building so that the background appears as a midtone and the building turns dark on film. But bear in mind that a dull, overcast sky usually creates a gray, uninteresting picture. Wait for the opportunity to take a silhouette picture when there is a dramatic sky behind the subject, as above. Alterna-

tively, photograph into the sun, composing the picture so that the sun lies directly in line with the building and the camera. Often, a map can help you to work out where to set up the camera so as to frame the building against the rising or setting sun, as the box opposite explains.

Generally, buildings appear as outlines only when you photograph them against the sky from low viewpoints. However, if a lake or river forms a background, the water may reflect the sky's brightness, enabling you to create a silhouette from a higher camera position. For example, the boat house at top right appears as a placid silhouette against the brightness of a lake.

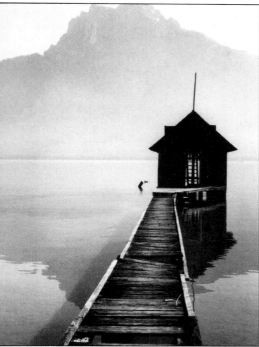

A boat house makes an angular black shape against a mist-shrouded lake. To prevent the derelict wooden building from looking too heavy in the picture, the photographer chose a camera position that showed the view through the open door, with a rectangle of slatted light breaking the pattern.

Bronze figures top a triumphal monument, and threatening stormclouds behind reiterate the heroic theme. The photographer took a meter reading from the sky, then closed down the aperture one stop further to dramatize the contrast between the statues and the clouds.

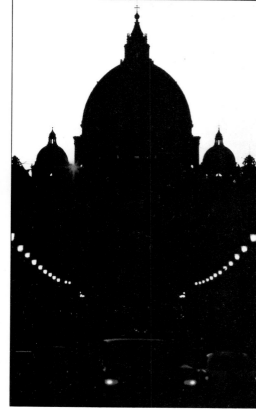

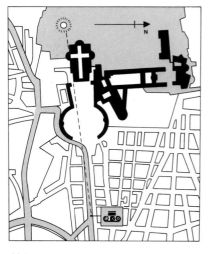

Using a map
If you aim to silhouette a building against the sunset, a map may help you find the best viewpoint. Before he took the picture at left of St. Peter's, Rome, the photographer used a compass to find the exact angle of sunset. On a map (above) he drew a line at this angle from the church and found that a view from the Via della Conciliazone would show the sun setting behind the dome.

Looking for detail

Closing in on small elements of a building can reveal a surprising amount about its structure and style.

Often, spotting revealing details is just a matter of remembering to look upward. However, as in the picture below, the most interesting patterns sometimes appear only when you take your camera up to a high viewpoint – the balcony of a building opposite, perhaps – and use a telephoto lens. But with a long lens, be sure you have the camera steady, and set an aperture small enough to give sharp focus to the whole of the detail you want to show; precision is important in most architectural pictures.

At ground level, consider the graphic potential of close-up views. Sometimes, waiting for the right lighting conditions can lend impact to an ordinary detail, as in the shadow composition on the opposite page. And in extreme close-up, structural details sometimes become bold abstracts of the kind seen in the picture opposite at bottom left. Look out, too, for small-scale details of decoration – friezes, sculptures and motifs such as the carved insignia on the opposite page.

The flying buttresses of a cathedral might look identical from ground level. But a 300mm lens reveals that every single finial is different: a testimony to the skills and ingenuity of the medieval craftsmen.

Shadows on a sunny wall
counterpoint the lines of a
window and venetian blind.
The photographer took her
reading from the white wall
and opened up by one stop.

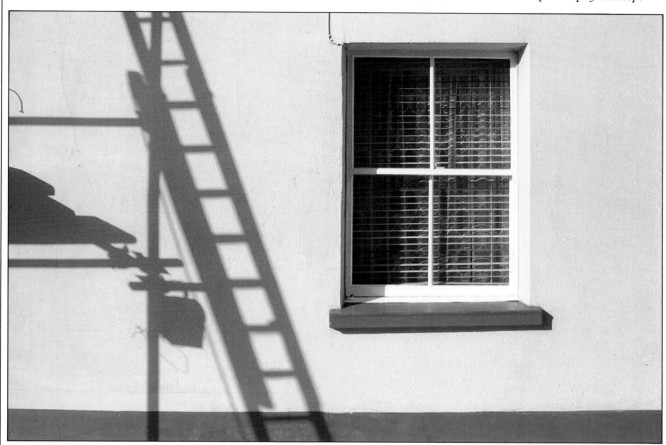

White battlements *on a
Greek lookout tower become
abstract shapes in close-up.
The photographer used
a 35mm lens to change the
scale relationship between
the blocks and the far hills
and to keep both in focus.*

Weathered old wood *and
mellow brick give a splendid
contrast of textures. To bring
this out in a high-quality
image, the photographer
used a normal lens and a
slow color slide film
(Kodachrome 25).*

Finding patterns

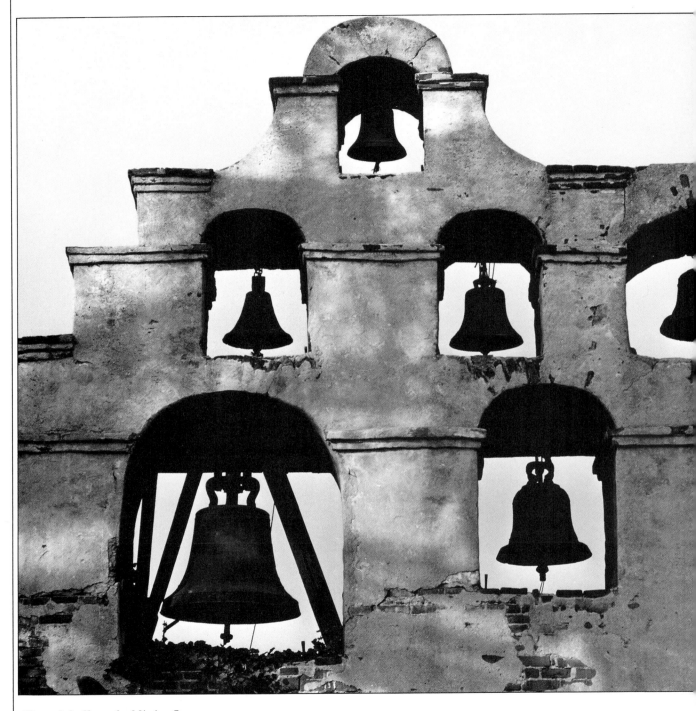

Church bells *at the Mission San
Gabriel Archangel in Los Angeles hang
silent in their wall of arches. Close
framing with an 80 mm lens excluded
the context to emphasize the interplay
of shapes. By revealing the underside
of the arches, the low camera angle
strengthened the pattern.*

Patterns in architecture offer excellent opportunities for semi-abstract compositions, which can look especially dramatic in black-and-white. To emphasize pattern, you need to draw attention to repetition. One way of doing this is to use a telephoto lens to reduce perspective, so that objects at different distances from the camera seem to be brought together on the same plane, as in the composition below. Look also for opportunities to strengthen patterns by the use of light and shade. The picture of the church bells at left gains impact from the deep shadows on the underside of the arches. In a darkroom, you can bring out such graphic qualities by printing on high-contrast paper.

Viewpoint is also important. Usually, the greater the number of repeated elements you can squeeze into the frame, the more effective the pattern will be. For example, with a subject such as terraced housing, a diagonal view that overlaps identical lines and shapes will make the strongest image. To exaggerate a pattern still further, crop in tightly to exclude the edges of the subject, another reason for using a telephoto lens.

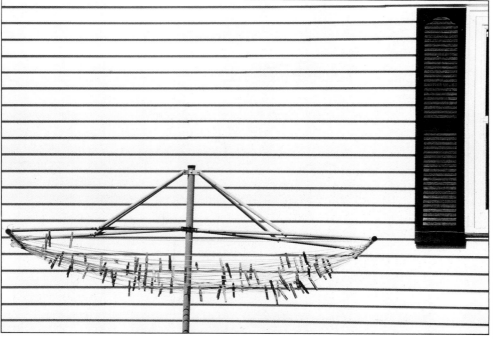

A timbered wall of a house in Maine is the backdrop for a forlorn clothesline. The window frame and shutter help us to "read" the picture without detracting from its spare, abstract quality. To give a two-dimensional effect, the photographer closed in with a 200mm telephoto lens.

Using reflections

Reflections of buildings open up many creative possibilities for combined or double images that add color or heighten the graphic impact of pictures. For example, in the photograph of a Boston skyline at bottom right, shimmering reflections in a wide expanse of water add movement to a conventional view and emphasize the height of the skyscrapers.

A closer view of modern structures and their reflections can produce almost abstract images, as in the composition opposite. Glass-walled buildings, in particular, sometimes act like giant mirrors, giving intriguing multiple reflections. The effect is most spectacular when the sun is low and you use a long telephoto lens from a distant viewpoint.

Another approach is to use reflections to combine a detail with a general view. You could use a window in a courtyard to reflect part of the surrounding buildings and suggest the scale of the architecture as a whole. Irregularities in the glass, a feature of older windows, can give interesting distortion effects, as in the picture below. For more exaggerated distortion, look for reflections in convex surfaces – the striking image at the bottom of the page is an example. When you include both the original subject and its reflection in the picture, average the exposure between the two areas.

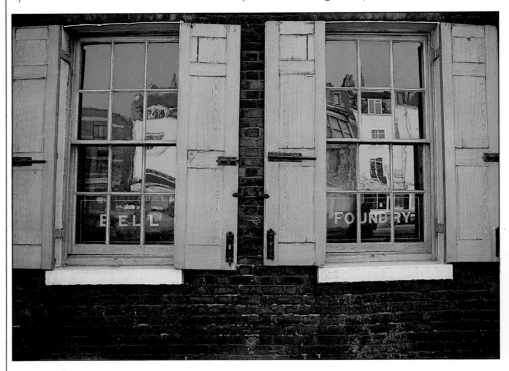

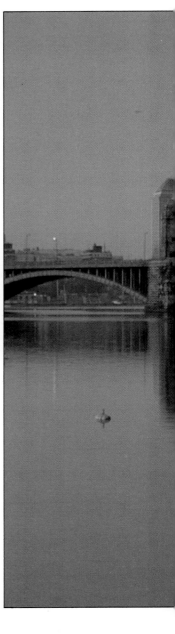

Wooden shutters (above) frame a view reflected in the windows of an old bell foundry in London. Thus the image effectively combines a detail with a setting that puts the subject in context.

White gables (left) against a deep blue sky are crisply mirrored in a car roof. The distortion caused by the convex surface gave the image a bold asymmetry.

A skyline view (*below*) of Boston at dawn is echoed by reflections on the water. The composition, taken with a 135 mm lens, brings out the warm colors of the buildings in the early morning light.

Wet pavements (*left*) in Bordeaux after a storm accentuate modern geometric lines. The photographer used a 105 mm lens and took his reading from the sunlit wall to obtain graphic contrasts.

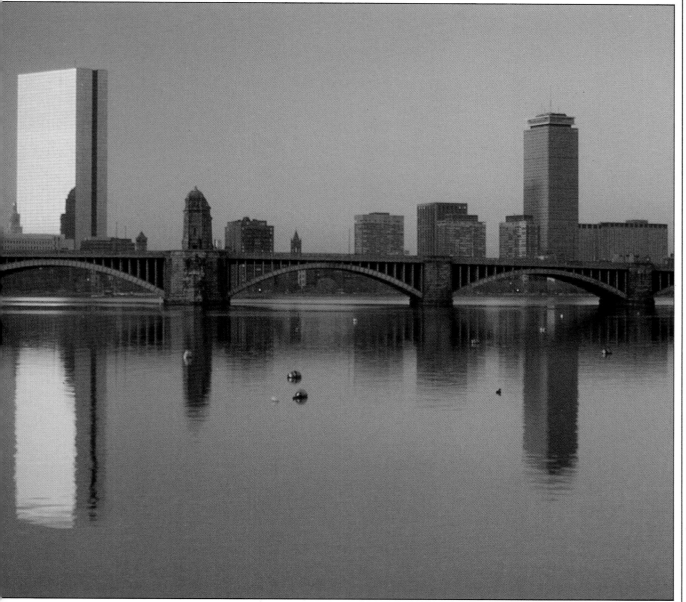

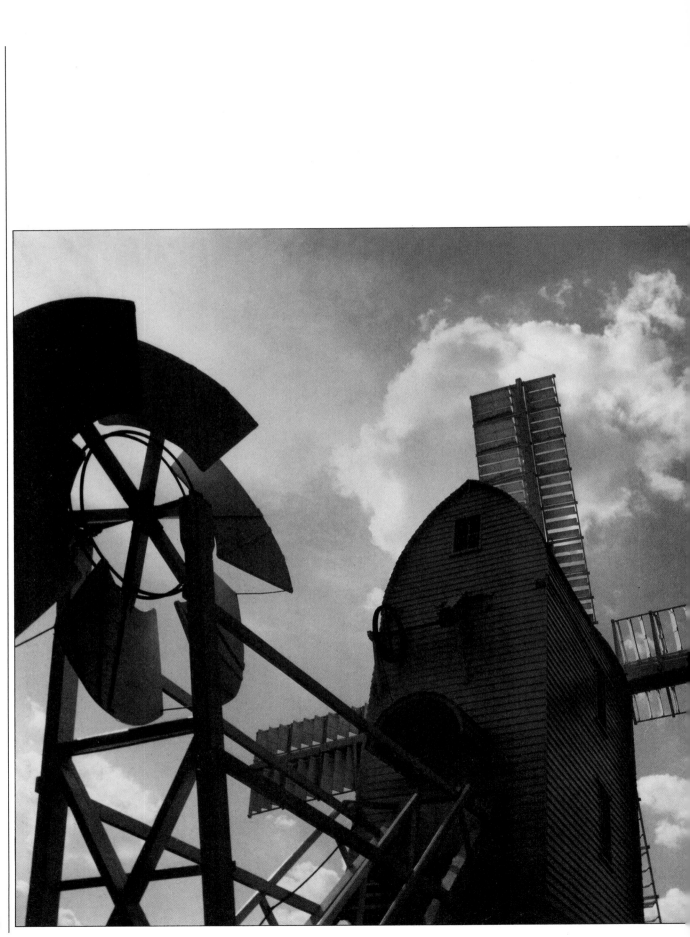

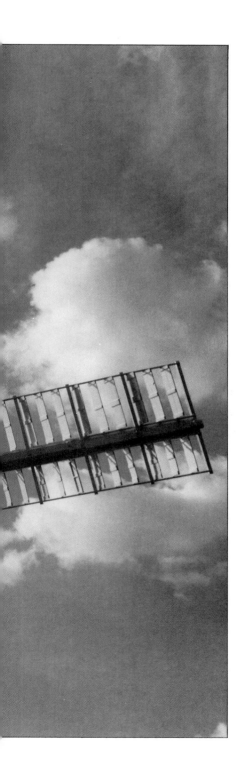

PORTRAITS OF BUILDINGS

When you photograph single buildings, your aim should be to reveal their character. The skills required to do this are in many ways similar to those for human portraiture. To produce an image as striking as the one at left, you need to decide which features are most important visually; then you need to consider what choice of lens or lighting, framing or viewpoint will enhance these features and play down those elements that detract from them.

The following section discusses specific techniques you can use to exploit the diverse qualities of buildings, from ordinary family homes to the exciting extremes of modern city architecture. How to suit composition to the style of a building; how to manipulate scale and perspective; how to make use of lighting, both natural and artificial; when to include surroundings for atmosphere and when to exclude them for impact – all these decisions can increase your control over the image. And they also form a sound basis for tackling the broader, more complex photographic subject of whole communities and cityscapes.

A lofty windmill is outlined against scudding clouds that suggest the sails' movement. A wide-angle lens accentuated the shape of the fan at far left and extended the depth of field for precise detail.

Judging exposure

Under an overcast sky, or in weak, hazy light such as that chosen for the picture of Siena Cathedral below, buildings pose no greater problems of exposure than do any other outdoor subjects. However, on sunny days, the sharp angularity of many buildings presents special difficulties of high contrast. Although slanting sunlight is ideal for a crisp rendering of texture or relief detail, large black shadows can be a distinct disadvantage.

Since the eye adjusts rapidly to differences of brightness, the only way to tell whether contrast is excessive is to take two separate small-area readings, one for the lightest significant part of the scene, the other for the darkest. For each reading, move in close with your meter. If this is not feasible, you can take exact readings from a distance with a spot meter; or if your camera has through-the-lens (TTL) metering, a useful trick is to attach a telephoto lens and then zero in on each of the two areas.

Once you have measured the subject brightness range, the next step is to compare it with the range of exposures that your film is capable of recording, Color negative film can successfully record a brightness range of some seven stops, so setting the exposure midway between highlight and shadow reading will show all important details – provided the negative is printed carefully. Color slide film cannot accomodate such a broad range of exposures – five stops is about the limit – so detail will be lost in either shadows or highlights. Usually in architectural photography, filled-in shadows are more acceptable than bleached highlights, and can often make a contribution to the mood of a picture, as in the Boston street scene at right.

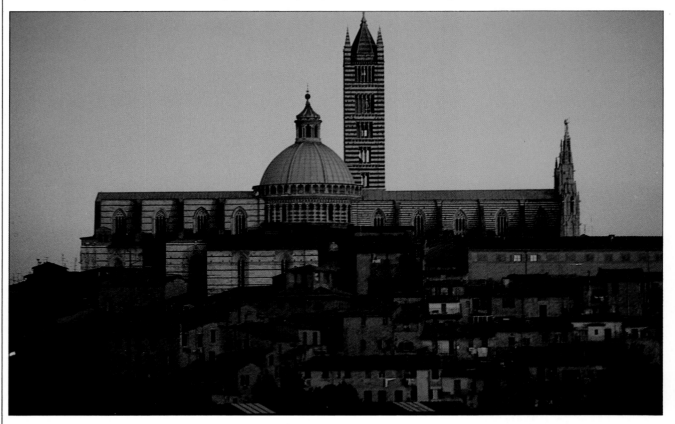

The zebra-striped cathedral of Siena, Italy, sprawls on a hilltop in pale winter light. Using ISO 64 film, the photographer set his exposure at 1/60, f/16 after taking a meter reading from the foreground. A reading from nearer the skyline would have led to an underexposure of one stop, losing the subtle colors of the houses.

Balconies and shutters (right) in Boston catch the light of the late afternoon sun. By following a spot reading of 1/60, f/16 from the reflected highlights, the photographer ensured that underexposure would leave most of the scene in deep shadow but that the film would accurately record the gilded beauty of the facade.

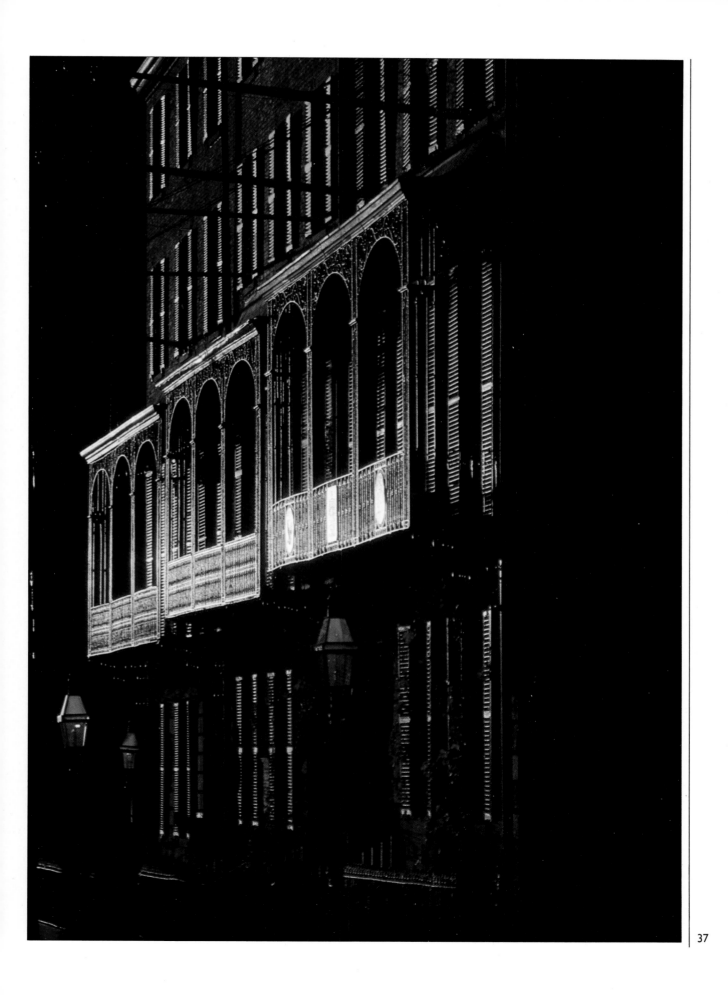

Using lenses

To extend the creative range of your architectural photography, a wide-angle and a telephoto or zoom lens are almost indispensable. They will enable you to photograph a subject from a much greater variety of viewpoints. And the optical characteristics of the different lenses will give you more range for imaginative effects, particularly through manipulating the proportions of buildings or their relationships with the surroundings.

For example, the picture below juxtaposes two domes on the same apparent scale. Yet the churches in Rome crowned by these domes are a quarter of a mile apart. The photographer has used the power of a 300mm lens to show their similarity of style in one compelling image. Although very useful for distant views of buildings, as well as for details, long

lenses have the inherent problem of shallow depth of field. Often you will need to make fairly long exposures using a tripod support so you can select apertures small enough to maintain an overall sharpness in the image.

With wide-angle lenses, foreground areas appear to expand and background details dwindle. One result is that unless you move in close, the sky tends to fill more of the frame. However, the looming of foreground features and the exaggeration of perspective can produce arresting images, especially if you can relate the building to objects close to the camera. By walking all round the barn shown on the opposite page, the photographer found an angle of view that transformed a mildly interesting subject into a fresh composition.

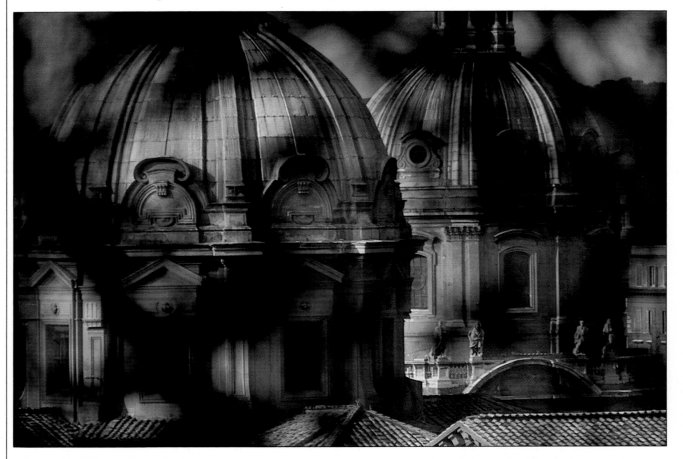

Through a 300 mm lens, the domes of SS. Luca e Martina and SS. Nome di Maria, Rome, are brought together in a view from the Palatine Hill. The lens has thrown out of focus a shrub just in front of the camera, which casts a web of soft shadows over the image.

Through a 28 mm lens, a red barn rises against the sky in brilliant contrast with a broad carpet of daisies. After planning his composition around the shape and color of the plain sidewall, the photographer used a polarizing filter for improved color saturation.

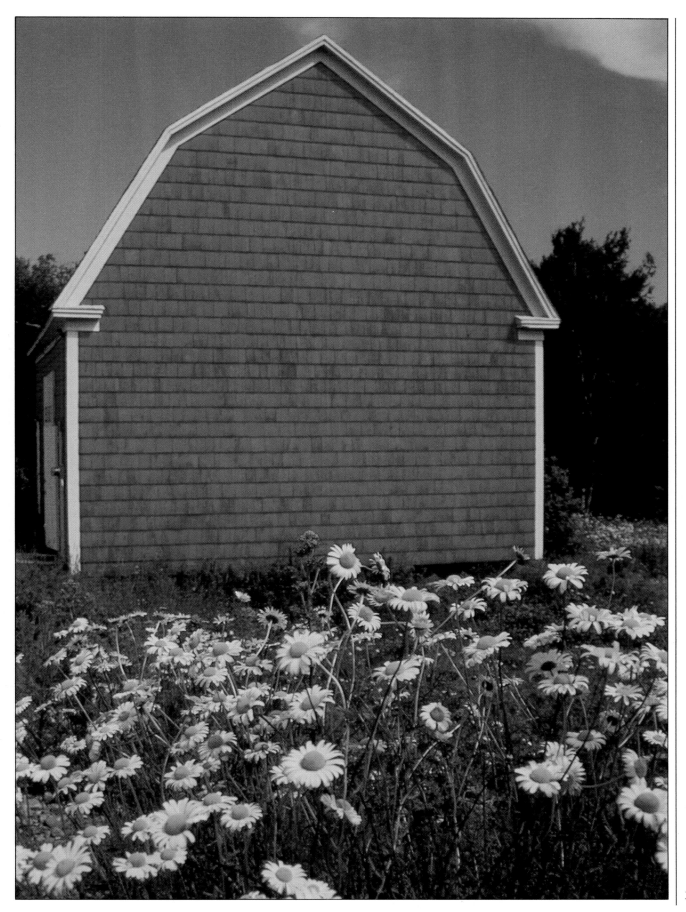

Aiming for accuracy

It is reasonable to expect that vertical walls should look vertical in photographs. Unfortunately, the laws of perspective often prevent this. If you tilt the camera upward to take in the top of a nearby building, as in the picture below at right, the verticals will converge and make the walls appear to lean inward – an effect known as keystoning. The eye sees the effect in much the same way, but it is far more disconcerting when the image is two-dimensional.

Various solutions to converging verticals are all based on the principle of keeping the camera horizontal. The most efficient technique is to use a perspective control lens (also known as a shift lens), illustrated below. As with the moveable lens panel of some large-format cameras, you can use this to take in the top of a building, not by tilting the camera but by displacing the lens upward in relation to the film.

With conventional lenses, there are other ways to avoid converging verticals. An elevated viewpoint, as in the picture below at left, often brings you more in line with the center of the subject so that you do not need to angle the camera. Alternatively, you can use a telephoto lens from a distance at which you can take in the whole building with the camera held level. Standing back with a wide-angle lens is also possible, although this will leave the building near the top of the frame and you will need to find an appropriate feature, such as a statue or flowerbed, to fill the foreground.

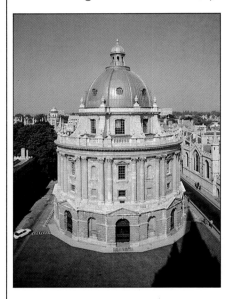

A high viewpoint (left) from an upper-story window ensures that the vertical lines are parallel in a portrait of the Radcliffe library building at Oxford University, taken with a normal 50 mm lens held level.

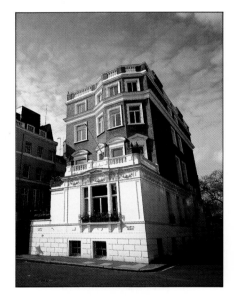

An inward slope (above) distorts this 28 mm lens picture of an imposing London townhouse, taken from eye level with the camera tilted upward to include the whole structure and a generous area of sky in the frame.

Perspective control (PC) lenses

The axis of the PC lens at right can be displaced by up to 11 mm in any direction. For example, moving the lens upward shifts the field of view upward, so that the subject appears to move down in the frame. Most such lenses have focal lengths of 28 mm or 35 mm. They are relatively expensive but are worth renting for accurate views of buildings. In addition to helping to keep verticals straight, they can avoid unwanted foregrounds. They work best at small apertures and need manual adjustment of the diaphragm before each exposure. A knob or ring controls the shift.

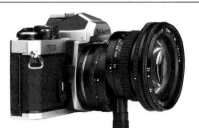

28 mm PC lens

Centered

With shift

Straight verticals (right) show the correction effect of a 28 mm PC lens used from the same viewpoint that produced the photograph above. The lens shift allowed the photographer to gain height while holding the camera level.

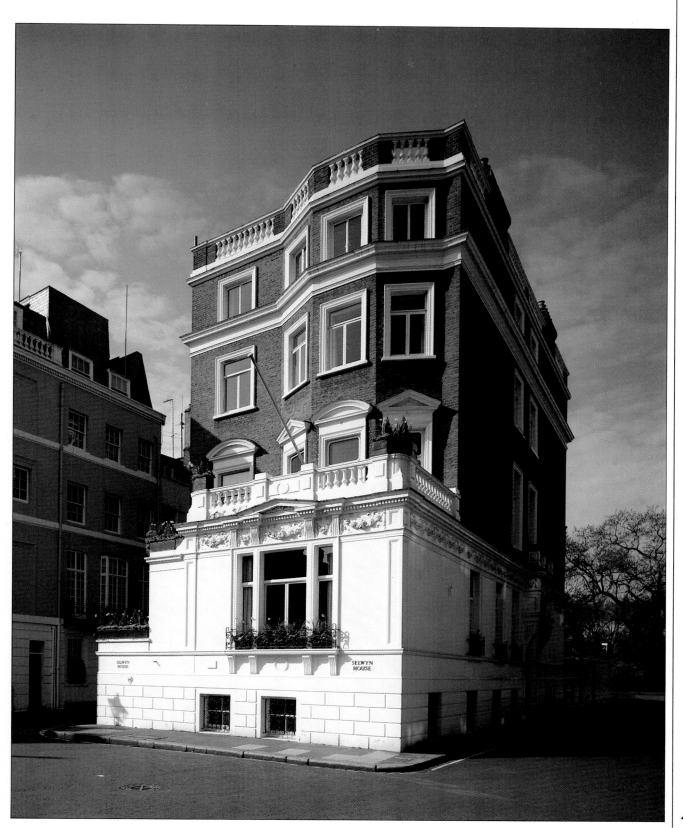

Aiming for drama

By textbook standards, the convergence of vertical lines in a photograph of a building is a distinct error. However, like many so-called errors in photography, it can be turned to creative advantage. By tilting your camera upward to exaggerate perspective, you can increase an impression of soaring height or monumental drama. Conversely, when shooting down from a high position, perhaps into a street or courtyard, convergence can give a feeling of vertigo. And the diagonal lines introduced into a picture by photographing a building obliquely often strengthen the overall composition.

To exploit convergence successfully, the secret is not to be halfhearted. Use a wide-angle lens, and step in close for a startling distortion of perspective. A wide-angle lens also allows you to include a foreground feature for a theatrical juxtaposition that balances the image, as illustrated by the two photographs below.

In cities you can sometimes produce a dramatic abstract picture by fitting an extreme wide-angle lens and aiming directly upward so that high-rise buildings enter the frame from all sides. A view directly up or down can also give exciting results in interiors, as shown by the photograph of a spiralling staircase opposite.

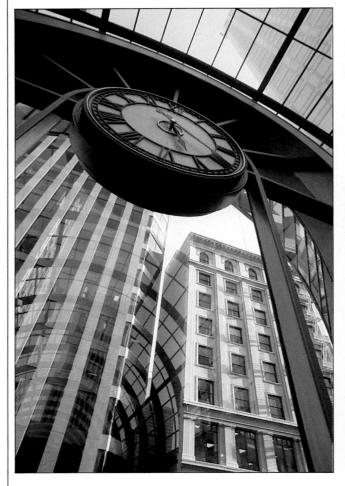

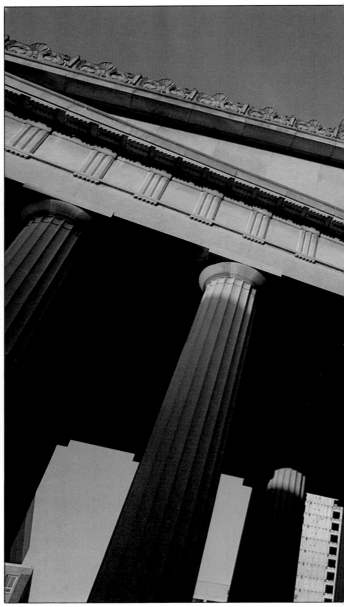

A clock suspended from an arch of iron is the point at which diagonal lines converge in an unusually framed view, through glass, of two high-rise buildings. To exaggerate the tilt of verticals and to achieve good depth of field, the photographer used a 24mm wide-angle lens.

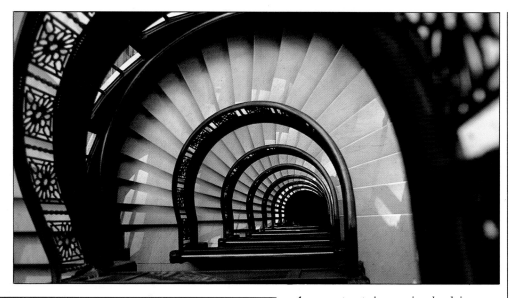

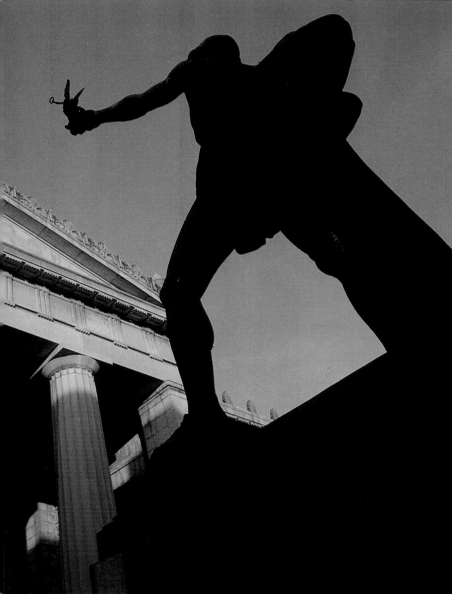

An ornate staircase in a bank in Chicago, seen directly from above, spirals gracefully into invisible depths. Although the perspective is exaggerated by the use of a 35mm lens, the effect is tranquil instead of dizzying, because the tunnel-like composition suggests a horizontal rather than a vertical view. With an exposure setting of 1/8 at f/5.6 on ISO 64 film, the photographer had to clamp the camera to the balustrade for this sharp result.

A statue, silhouetted by an exposure gauged from the sunlit facade, adds movement and mystery to a portrait of the classical-style war memorial in Nashville, Tennessee. A 28mm lens, used from a low viewpoint, made the columns seem to lean inward and backward, emphasizing the monumental character of the structure.

Simplifying the view

For a simple architectural portrait, finding an uncluttered view is one of the main priorities. In the center of a busy town or city, passing traffic, pedestrians, and smaller elements such as trash cans, bus stops and newsstands, may not only obscure views of a building but also create a confusion of detail that detracts from the main subject. To physically clear the view is impossible: you cannot stop the traffic or ask people to move away from an entrance. So you must rely on photographic techniques to overcome the problem.

A distant view and a long telephoto lens, set at a wide aperture to throw foreground elements out of focus, is one useful method. However, for subjects such as the one below – a public art gallery in the heart of a city – the special technique of using a long exposure to eliminate moving elements in the fore-ground can provide a better solution. Because extra-long exposure tends to produce a color shift on color slide or color negative film, this technique is best used with black-and-white film. To avoid overexposing the subject during a long time exposure, photograph in weak light on slow film, set a small aperture and, if necessary, use a neutral density filter to cut down the amount of light entering the camera still further.

Outside of towns, eliminating unwanted detail becomes easier. For the picture opposite, at top, the photographer moved in close to remove a crowded beach and outline the subjects against a plain sky. A carefully chosen viewpoint can make use of attractive surroundings to hide clutter and at the same time add to the mood of a portrait – as in the charming composition at the bottom of the opposite page.

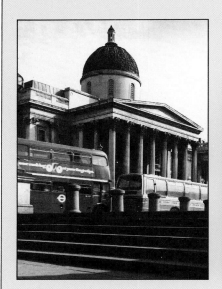
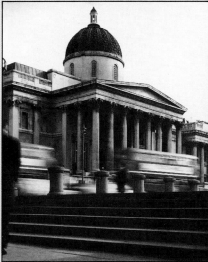
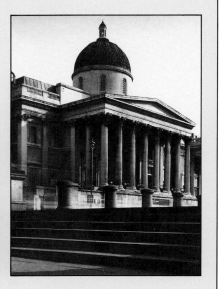

1 – **Two buses** – one a double-decker – obscure a view of the National Gallery in London's Trafalgar Square. The constant flow of traffic past the front of the building made an unobstructed view impossible on a normal exposure: here, the shutter-speed setting was 1/30 at f/16, using ISO 32 film.

2 – **Blurred images** of moving traffic and pedestrians, created by choosing a slower shutter speed of 1/15, simplify the view of the building and make the photograph slightly more acceptable by eliminating some of the more distracting details, such as the lettering on the side of the bus.

3 – **A clear view** results when the photographer increased the exposure to 15 seconds, so that moving vehicles almost disappeared from the scene, recording only as a faint blur. In order to cut down the light entering the lens by four stops, he used a 1.2 neutral density filter.

Painted beach houses (right) make cheerful abstract shapes against the backdrop of a cloudless sky. A 28mm lens pleasingly distorted perspective, and the close camera position cropped out the lower part of the structures, together with distracting details at ground level.

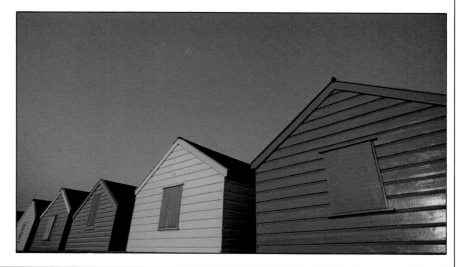

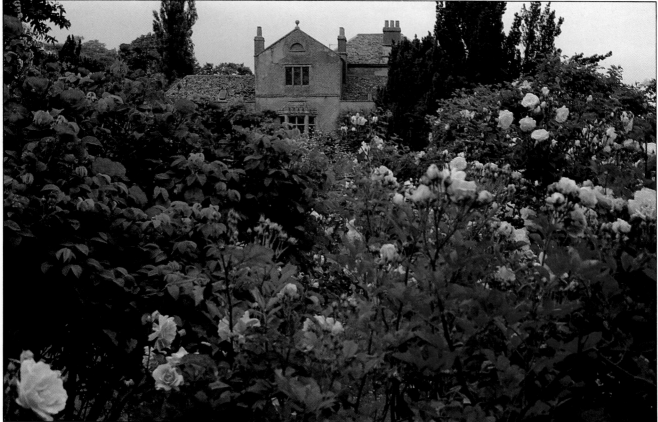

Dense rose bushes in full bloom frame an old manor house. The photographer was unable to find a close view that was uncluttered by vehicles or people. Instead, she chose to make the beautiful gardens an important feature of the portrait, and used a 35mm lens for good depth of field.

Portraying houses

Most domestic architecture is on a comfortable scale, designed for living in rather than impressing. The techniques for photographing public buildings apply as well to houses. But extra creative care is needed to show an ordinary family dwelling at its best and to bring out a personal character.

As a first step, particularly if the subject is your own home, try to shake off the familiarity of the building. Consider the house in the same objective, critical way that you would a grand piece of landmark architecture. Walk around to explore all possible viewpoints. The boxy shape of many modern houses can make a face-on view the worst choice. Instead try other camera positions to emphasize structural variety.

Use trees and other foreground elements to lead the eye into the frame and try to include the signs of life that give charm and individuality to a house. In the picture below, the immaculately preserved car reflects the owner's appreciation of a fine period building. Rear views often show more intimate, characterful aspects of a house. Consider, too, the advantages of photographing a house at evening: in the lower of the two pictures opposite, beckoning house lights and smoke curling from a chimney reinforce the feeling of a family home.

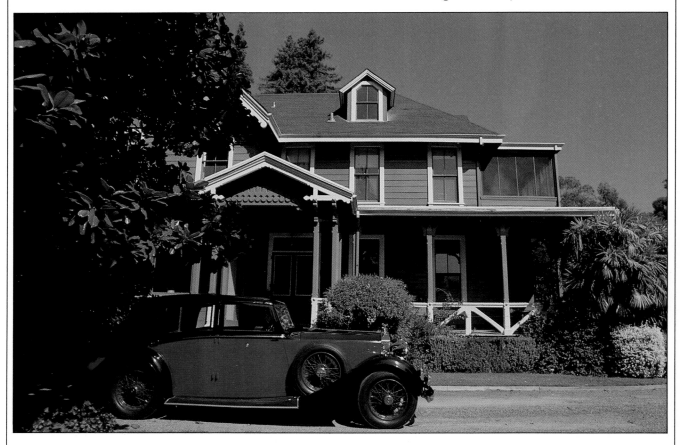

A vintage car in mint condition sits proudly outside a house in San Rafael, Califonia – and echoes the well-tended elegance that characterizes the residence. Foreground interest and a low viewpoint enhance the sense of depth and stature.

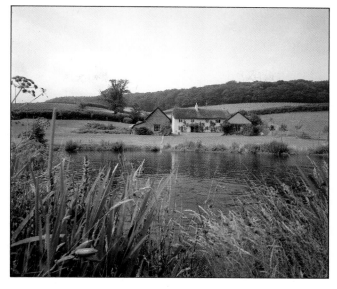

Lakeside plants (right) frame a view of a thatched farmhouse set in the verdant English countryside. ISO 64 film recorded the subtle hues of pink-washed walls, faded straw and old brick. A small aperture of f/16 gave the necessary depth of field.

At twilight (below) the farmhouse shown at left springs to life with glowing lights reflected in the calm water. Using a tripod, the photographer made an exposure of two seconds, maintaining an aperture of f/16 to keep the foreground in focus.

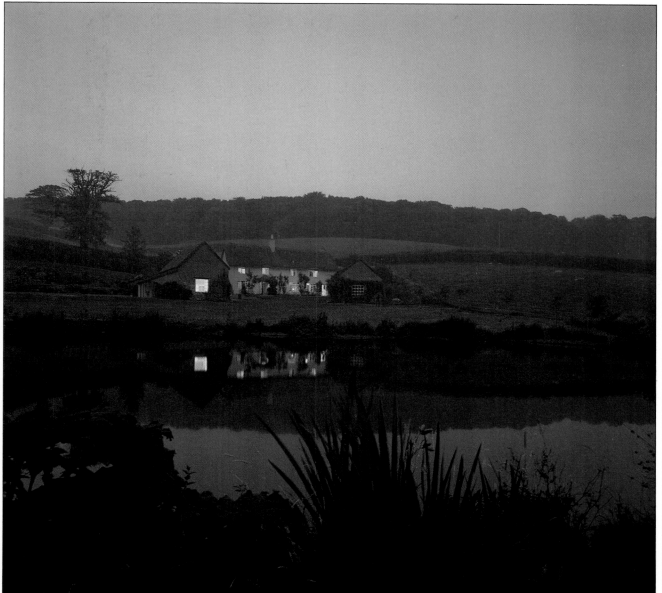

Conveying mood

One of the best ways to capture the character of a building is to use the light and colors of particular seasons or weather conditions to evoke an appropriate mood. Notice how the spatter of raindrops on the car in the picture below gives immediacy to a view of skyscrapers towering in the mist. The whole picture subtly conveys the sleek, sealed-off feeling of modern office architecture on a rainy day in the commercial center of a big city.

In complete contrast, the deep blue of a summer evening that fills about half of the picture at the top of the opposite page establishes a very different mood, appropriate to a small church in the Canary Islands — a sense of simplicity, space and perhaps loneliness, accentuated by a solitary figure and the formality of a paved courtyard. A closer view of the whole church might have missed these clues to the building's personality.

To use light and color sensitively, you need to identify the overriding impression that a building gives you and the aspects of its character that you want to emphasize. If you want to suggest history and heritage, autumnal hues and subtle lighting may help to turn back time and convey an impression of continuity, as in the picture of a church at the bottom of the opposite page.

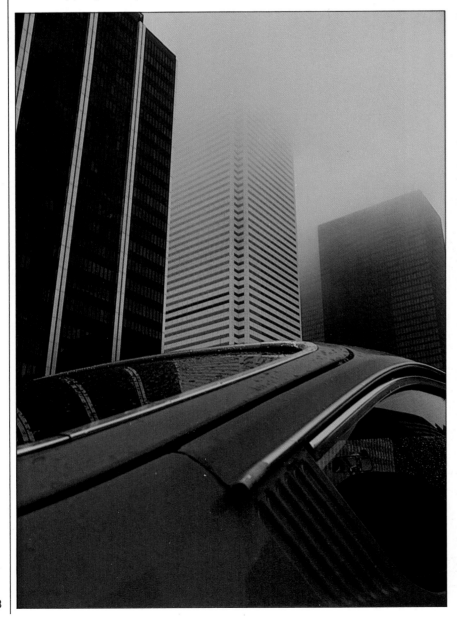

The streamlined back of a car breaks up the severe geometry of office towers in Toronto, the wet metal setting the mood of the picture. The photographer used a 28mm lens to exploit the curves and distorted reflections, choosing an exposure of 1/30, f/11 with ISO 200 film to record details crisply in the gray, misty light.

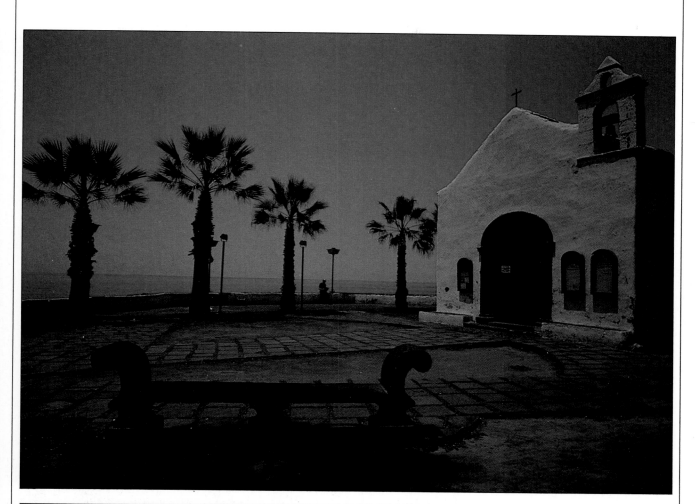

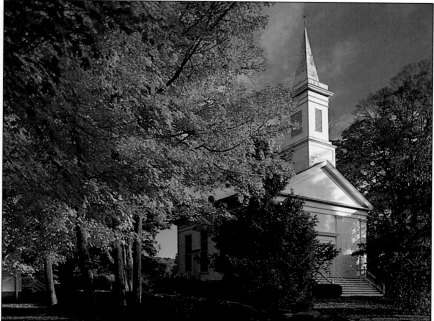

Palm trees and a low stone seat flank the approach to a simple church in the Canary Islands. The broad view and good depth of field of a 35 mm lens suit a composition in which the setting tells us much about the building. To enrich the blues of sea and sky and to reduce glare on the facade, the ISO 64 slide film was underexposed one stop.

Autumn colors and dappled light enhance a typical New England church in Connecticut. The play of light and shade establishes a mood of softness and harmony and also defines the building's form, sharply recorded on ISO 64 film at a setting of 1/30 at f/22.

The impact of the new

Modern architecture is often dramatic and eyecatching, not least because materials such as steel girders, reinforced concrete and plate glass allow structural solutions that were never available to traditional designers. And attitudes have changed too, so that many architects deliberately set out to break the rules, while their predecessors were concerned with continuity. Modern buildings that are exciting and original invite equally innovative treatment by the photographer.

The most fruitful techniques are those that play up the abstract qualities inherent in most modern structures. Close, oddly angled views that discon-

cert the eye, as in the picture at the top of the opposite page, make the most of clean, simple curves and crisp textures. Bold cropping used to isolate part of a structure from its context is also effective as a means of creating and emphasizing strong, abstract shapes: the composition below is an example. When the subject's background is a plain blue sky, a polarizing filter will enhance color contrasts. Sometimes an ingenious framing device can give fresh impact to familiar outlines. In the image opposite below, a fisheye lens distorted the shape of a plate-glass facade that reflected New York skyscrapers, producing a novel effect.

The sweeping curves of
a walled villa in Sardinia
are exaggerated by a tilted
wide-angle view. Deep shadow
brought out the building's
colors and rough texture.

Corrugated plastic
(below) provides roofing for
picnic shelters in upstate
New York. The photographer
used a 28mm lens with a
polarizing filter to deepen
the sky, exposing at 1/30, f/11.

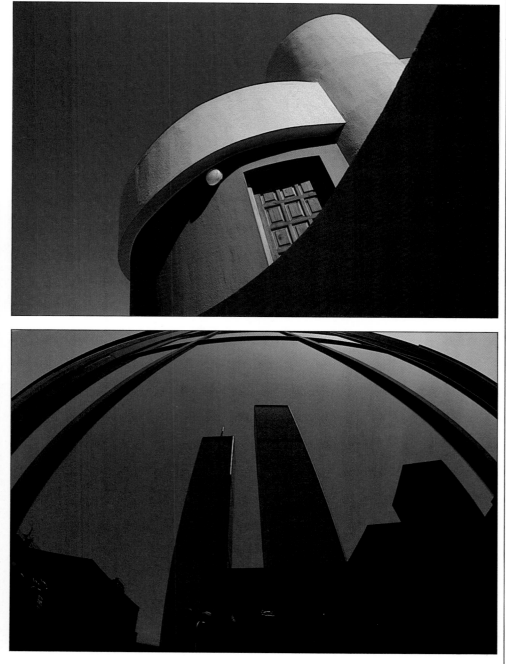

The twin towers of the
World Trade Center seem to
be enclosed in a steel and
glass dome. The effect was
created by using a 16mm lens
to photograph the reflected
image in the plate-glass wall
of another skyscraper.

Doors and windows

Photographers who wish to convey the character of a building in a single revealing detail are drawn again and again to doors and windows. With houses, these are usually the most personalized features. The plant holders, sheer curtains, name plate and unexpectedly decorative woodwork in the picture directly below say much about the house and its owner. By contrast, the entrance to a government building, at bottom, seems both impersonal and intimidating.

One attraction of photographing doors and windows is the neatness with which they can be framed, as all five pictures here demonstrate. For close framing, it is wise to carry a telephoto or zoom lens that enables you to get well back out of the way of traffic when photographing a street frontage. Set up the camera on a tripod at a convenient distance and use slow film for sharpness of detail. Long lenses are also useful for out-of-the-way features such as the window under a thatched roof at right.

Windows can make equally rewarding subjects from the inside, as shown by the picture at the bottom of the opposite page. The photographer stood to one side of the window so that the contrast between the landscape outside and the dark interior was not as extreme as it would have been had the sunlit sky filled the entire window area.

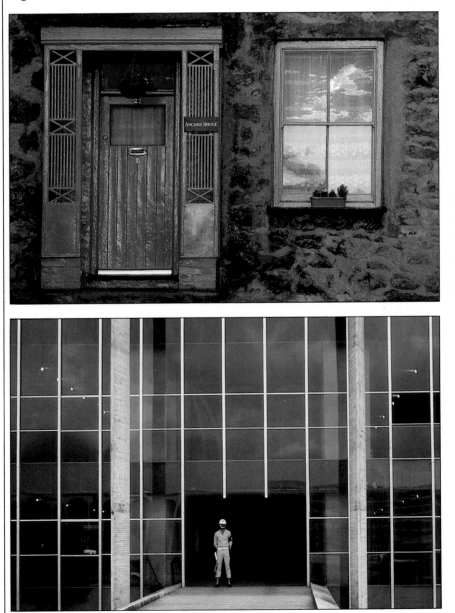

A green door and a window set into a rough stone wall display pleasing contrasts of texture and color, sharply recorded on slow film (ISO 25) with a 105mm lens on a tripod-mounted camera. The photographer waited until early evening, when the setting sun brought out the gloss of the paint and gave a dramatic reflection of clouds in the window panes.

A dark entrance, guarded by an armed sentry who looks dauntingly across the walkway, suggests an atmosphere of high security in this ultra-modern office building in Brasilia. From a distant position, the photographer closed in with a 200mm telephoto lens.

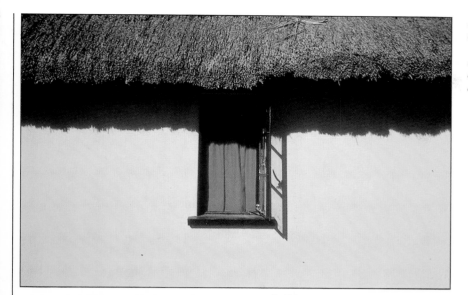

A thatched roof in bright sunlight deeply overshadows an open window. The photographer used a 105 mm lens and placed the strong red square of the curtain exactly in the center of his semi-abstract composition.

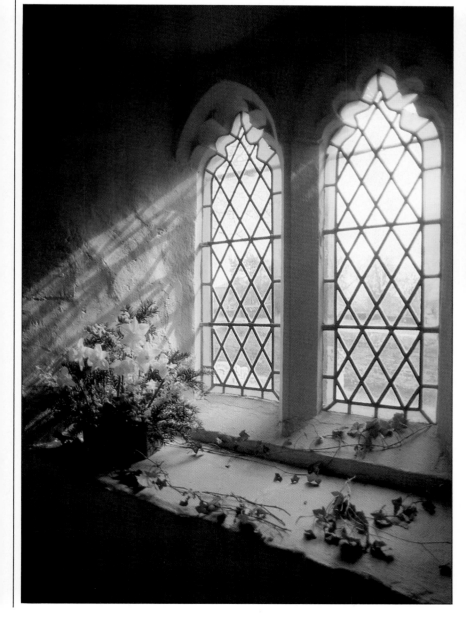

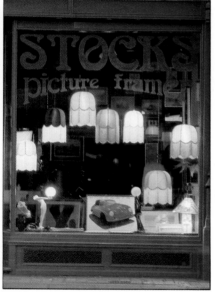

A shop window exhibiting an array of hanging lamps draws the eye slowly into the dim, cluttered interior. By closely framing the sides of the window, the photographer created a visual pun — the framer framed. Daylight film enhanced the warmth of the lamps.

Stained glass in a rectory window adds a restrained touch of color to winter light pouring through diamond panes. The scattered petals evoke a mood of nostalgia. An exposure reading taken from the window ledge provided adequate detail for the interior and bleached out the unwanted scene outside.

Buildings after dark

Artificial lighting at night can transform the appearance of buildings. Important public edifices are often displayed in floodlight, giving theatrical impact to monumental designs such as the one below at left. Apart from the visual drama, floodlighting serves to isolate a building from its environs, and this can be invaluable if daytime views are marred by other structures: for example, a jumble of commercial buildings behind a fine old church.

The mixed nighttime lighting in towns and cities is difficult to balance on color film. Film balanced for tungsten light will correct the color of domestic lighting, but sodium-vapor streetlighting will retain a greenish cast. Rather than striving for a natural result, you can exploit the drama of mixed artificial light to the fullest by using daylight film. The center picture below shows how successful this can be.

To reveal more of a building's form, try taking photographs as dusk fades into darkness or as night gives way to dawn. At these times, natural and arti-

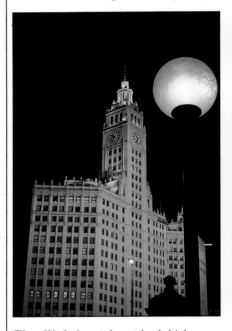

Floodlighting (above) lends high-contrast drama to the imposing frontage of the Wrigley building in Chicago. A streetlight provides warmer light to balance the cold blue cast from the floodlight. The photographer used a shutter speed of one second at f/4 with ISO 64 film.

ficial light are finely balanced, and you can create beautiful effects with the delicate colors, as in the image below at right.

The unevenness of the lighting in night scenes makes gauging exposure tricky. Depending on the level of light and the amount of reflection, you may need to set a shutter speed of anywhere from 1/30 to several seconds or longer. The safest approach is to bracket exposures one or even two stops each way if you are uncertain.

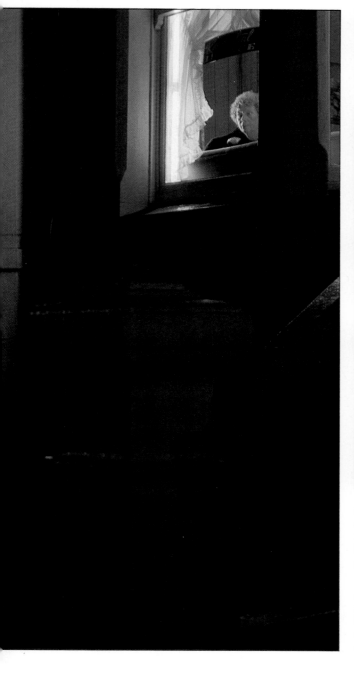

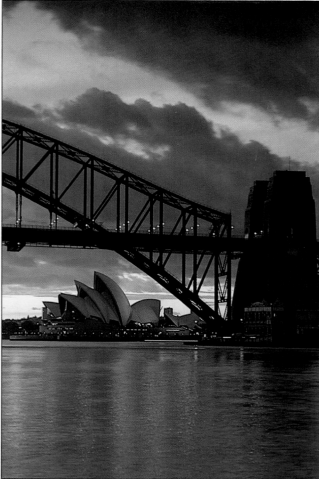

Dawn breaking over Sydney harbor in Australia (above) creates vivid reflections that blend the colors of the sky with the bridge and shore lights. The photographer exposed at 1/30, f/4 with ISO 200 film.

Mixed lighting (left) imparts glowing theatrical colors to an English seaside boardinghouse. ISO 200 daylight film exposed at 1/8, f/2 intensified the color casts given by the different artificial lights.

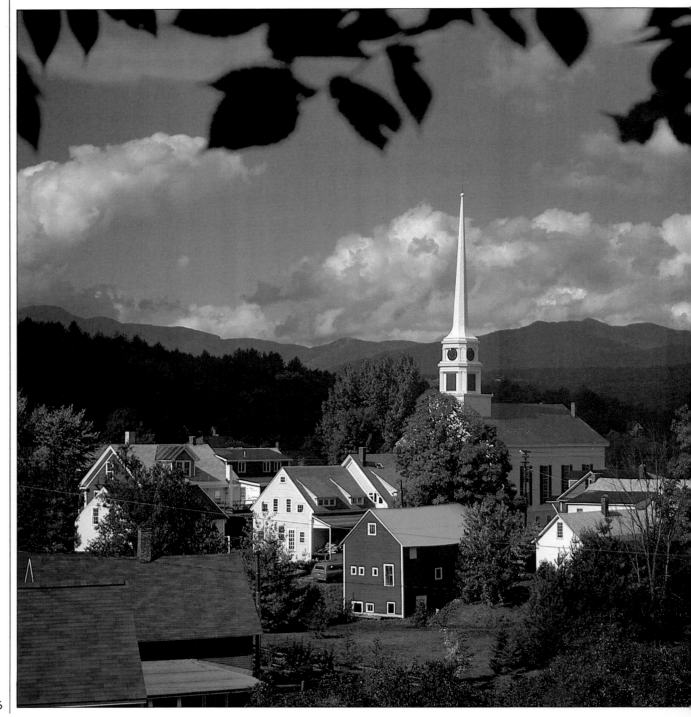

VILLAGES, TOWNS AND CITIES

The progression from a single structure isolated by the camera to buildings grouped in a settlement involves more than just a change of scale. In the broader view of a village or city, individual features of architecture are subordinate to the way in which the buildings relate to one another. Similarly, the mood and character of a particular building become less important than the overall impression of the location and community.

Conveying communal identity, whether in a great city or a tiny hamlet, requires some thoughtful planning of composition. Every community has a pattern that gives it unity, even where development seems quite random, but this may not be immediately obvious. You will often need to impose unity – perhaps by the way you frame the subject, perhaps by taking a high or distant viewpoint that emphasizes some pattern made by the arrangement of buildings. Look especially for a strong focus of interest to draw disparate elements together, as in the scene at left, where the church provides a natural focal point that pulls the scattered buildings toward the center of the frame.

The little town of Stowe
nestles among the woods and
hills of Vermont. Overhanging
leaves prevent the eye from
traveling above the spire –
the focus of interest – and
so out of the frame.

Organizing chaos

Visual disorder is a feature of urban environments in which the pressure for space has resulted in new development being squeezed in among existing structures. The concentration of life itself tends to produce untidiness and clutter, and the camera, for better or worse, records it all. Thus, bringing order to city- and townscapes often entails a very careful choice of subject, viewpoint and lens.

No matter how disorganized the subject matter appears, by finding a strong pattern or point of interest you can guide the viewer through the scene and bring unity to the image. One simple trick is to include an ordered foreground pattern such as a flight of steps, railings or cobblestones, to provide a frame or lead-in for a view that otherwise lacks coherence. In the picture at the bottom of the opposite page, the framework of stairs and fencing divides a complex scene into regular, abstract shapes. The photographer deliberately sought out the viewpoint within a fenced-off area so as to superimpose the strong stairway pattern upon the backlit triangle of red plastic, which makes an immediate point of interest. Another technique is to use lines leading into the picture from the edges of the frame, as in the photograph below.

With views of closely packed streets, you can use a telephoto lens to compress perspective and crop in tightly on an untidy scene. The flattening effect of the long focal length can reveal an orderly pattern, as in the image at top right.

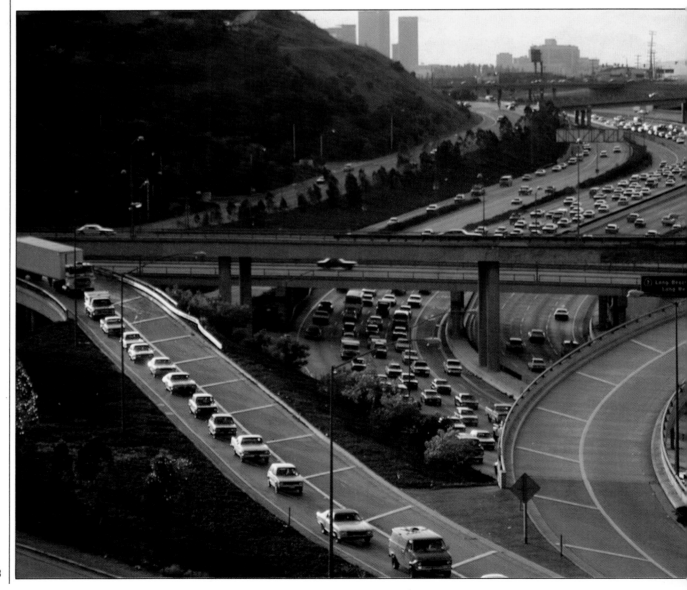

A demolished dwelling
(right) breaks up the line
of houses in a Welsh town
and draws attention to the
tipsy angle of the roofs. A
200mm lens reduced distance
to give unity to the scene.

The serpentine curves
(below) of freeways lead the
eye back to the Los Angeles
skyline at sunset. A high
viewpoint with a 135mm
lens revealed the pattern of
intersecting roadways and
lines of traffic.

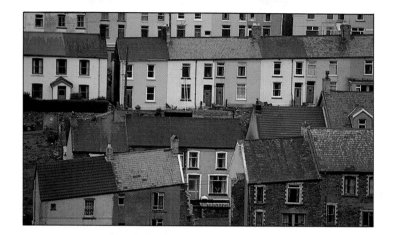

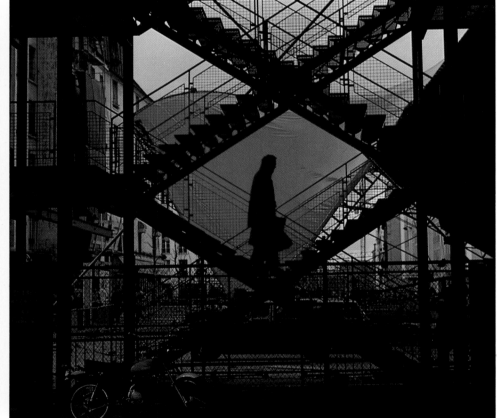

Iron stairways (above)
provide an intriguing frame
for a sculpture on display
near the Pompidou Center in
Paris. Including small areas
of red to pick up the color
of the sculpture helped pull
the complex elements into a
harmonious whole.

Looking down

A high viewpoint has obvious advantages if you want to give an impression of the size or layout of a place, or to photograph it in its setting by means of a panoramic view. However, from an elevated vantage point such as a high window in a tall building, consider whether you could also make an effective composition by aiming the camera steeply downward, to reveal patterns and perhaps pose intriguing riddles. For example, in the picture below the directly overhead view of a decorative pavement in Rio de Janeiro is scattered with details that the viewpoint and scale teasingly prevent us from identifying with certainty. And in the photograph of the Belgian marketplace on the opposite page, the gray shapes are clearly market stalls, but the camera angle is such that the goods for sale are hidden.

For the greatest choice of pictures, take along a range of lenses – a normal and a wide-angle lens for broad views, and a long-focus lens for emphasizing patterns by flattening perspective. A zoom is especially useful for offering a range of focal lengths in one body but if you have only a medium telephoto lens you can double or treble its length with a teleconverter, though with some loss of quality.

Scan the rooftops for antennae, smokestacks or other details that might make interesting compositions in close-up. In a town or city built on hilly ground, a zoom or telephoto lens used from one of the crests will sometimes enable you to fill your frame with the throb and color of street life, as in the photograph at near right.

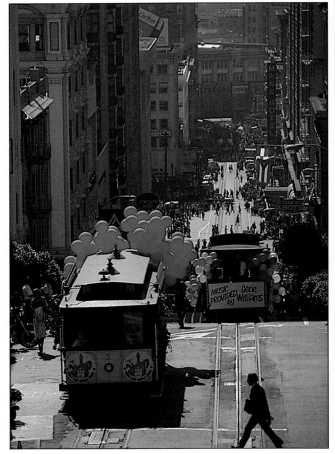

Cable cars and balloons (above) make a colorful foreground to a view along California Street in San Francisco, taken with a long 200mm lens to flatten the perspective. Shooting into the sun, the photographer used a lens hood to prevent flare.

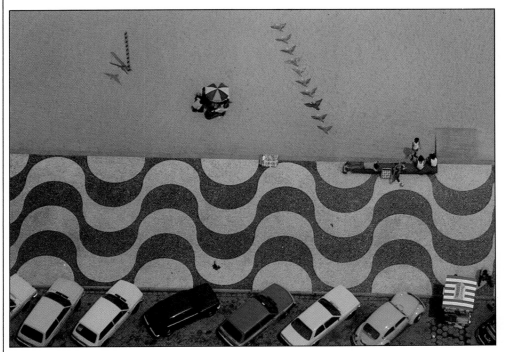

A mosaic pavement fronting Copacabana Beach forms an eye-catching pattern in a view taken directly downward from the window of a hotel, with a 35mm wide-angle lens.

Picturesque facades in *Bruges, Belgium, look out over a gray, rain-soaked market scene. A high camera angle brought out the contrast between stalls and buildings.*

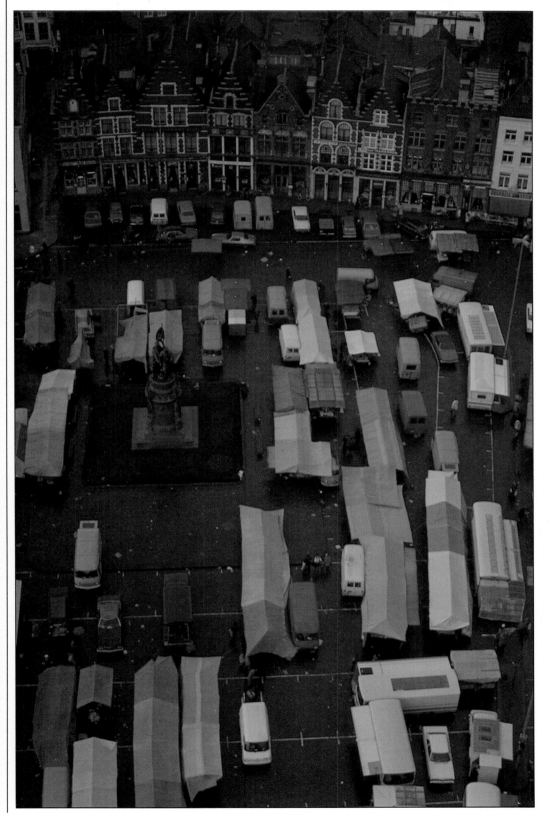

Urban skylines

The overall character of a city shows up most clearly in its skyline. Think how the soaring, box-shaped skyscrapers of a modern American city contrast with the domes, spires and turrets of some historic European cities. Sometimes you may be able to get an excellent skyline view from high ground or the top of a tall building. Such comprehensive views from a height are often most effective under a cloudy sky, as in the picture on the opposite page at

bottom, or at dawn or sunset.

In the middle of the city, nearby buildings often block out the horizon, breaking up the rhythm of roofs. To get around this problem, head for the city's open spaces. From a patch of green or an area of water you will often get an unobstructed view of the distant buildings, as in the picture at the bottom of this page. If the open space you choose is quite small, as many city parks are, you may have to use

Manhattan's famous profile stands out against a clear blue sky in this view from a sightseeing boat. A 28mm lens took in both the sunlit buildings and their dim reflections in the water below.

a wide-angle lens for a good view of the skyline. Such a lens takes in large areas of foreground, so pay special attention to this part of the scene.

Even a wide-angle lens cannot capture the broad, shallow panorama of a skyline as the eye scans it. For this, you need to make a series of exposures and to join them together. Or, you could rent a special panoramic camera such as the one diagrammed at right, used to take the picture immediately below.

The Globuscope camera
This panoramic camera, shown at left, incorporates a clockwork motor. The camera body spins rapidly while the lens scans the surroundings through a slit, building up a continuous image in strips on a long piece of film. As the motor keeps the film in pace with the rotating lens, there is no blurring, and the camera can expose a full 360° view.

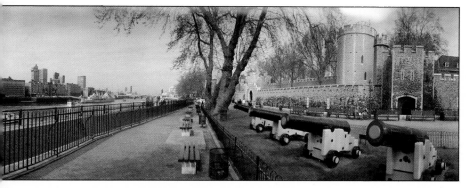

The Tower of London faced the slit of a Globuscope camera at the beginning of this panoramic picture. As the camera rotated, it showed the embankment at right angles to the starting position, the railings immediately behind (which seem to bulge), the embankment stretching away on the other side and the Tower reappearing. The photographer crouched below his tripod to avoid appearing in the scene.

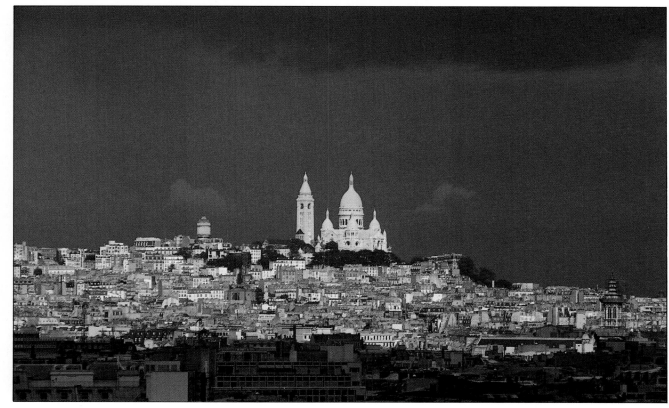

The Paris skyline is recognizable from the famous white church of Sacré Coeur, set against a dark sky. The photographer went north, beyond the tourist area, for a high viewpoint.

Color in the city

A gurish neon sign (left) and a bank of brilliantly colored tubes advertise the entrance to an amusement arcade. The photographer underexposed the slide film by one stop at 1/30, f/2.8.

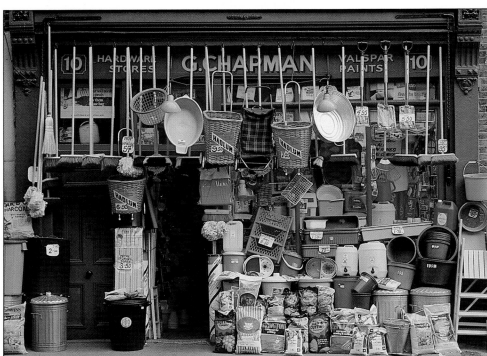

The overall impression of city streets can be one of uniform grayness. For this reason, color in buildings, window displays or signs has a special attraction, and images that exploit this visual element can provide a refreshing contrast to more standard city views.

With good framing, quite small areas of color can make a vivid impact. Moving in close or using a telephoto lens to fill the viewfinder with the subject will help to concentrate the colors, especially if you can frame them against a dark background, as in the two pictures above. To intensify the colors of neon signs when using slide film, try underexposing by one-half to one stop.

Lighting conditions affect the color saturation. Try to take your pictures in hazy, diffused sunlight, which reduces reflections and so makes colors richer and deeper. A polarizing filter will further strengthen colors as shown in the photograph opposite.

Assorted goods (above) crowd the pavement as well as every inch of shopfront outside a family hardware store. Tight framing to crop out the surroundings helped to emphasize the pattern of colors made by the display.

A streetcorner bar in
*Los Angeles forms a vibrant
contrast to the blue walls
of the Pacific Design Center
rising behind. A polarizing
filter reduced glare and so
intensified the rich colors.*

Streets at dawn

In towns and cities, the hours around dawn provide a tranquil lull in the relentless activity of urban life. Except in areas famed for their nightlife, such as downtown Las Vegas, the streets are usually deserted and their stillness can seem almost eerie.

This quiet mood is one good reason to photograph streets at dawn. But there are practical advantages too. The varied and swiftly changing light at this time of day can show buildings to striking effect. On a misty morning before the sun appears, the diffused, shadowless light gives a pale simplicity to structures: as in the scene at the bottom of the opposite page, where the soft colors of the skyline provide a backdrop to the warm gleam of artificial lights. As the sun comes up, its low, acutely-angled

rays will catch the edges of buildings to reveal their structural lines. A high viewpoint, used to take the picture below, can bring out such patterns in a graphic way. At ground level, the golden light of the rising sun plays across surfaces to show texture and form and creates beautiful backlighting effects, as in the evocative image at right.

The other great advantage of taking photographs in the early hours is that you have clean, uncluttered views of buildings, streets and squares. Remember, however, that a completely deserted scene may look static. In each of the pictures on these two pages, signs of life – streetlights, a few autos and some early pedestrians – heighten the overall impression of still, quiet solitude.

The first rays of the sun strike parapeted roofs and the hoods of cars as a main street comes to life. The photographer exposed for the highlights – at 1/60, f/16 – to accentuate the angular pattern of the rooftops.

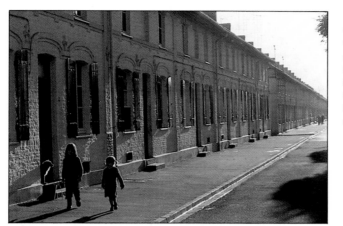

The soft clarity of dawn light reveals textural detail in a street of old houses in France and gives a rimlit aura to early risers. The oblique, diffused light and the long shadows work with the receding lines to give a strong sense of distance.

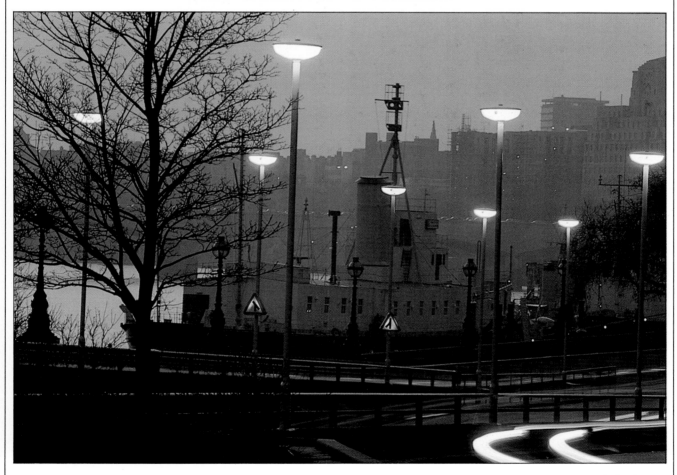

Streetlights and glowing streaks from traffic enliven the delicate, misty tints of London's Embankment at dawn. The photographer set a long exposure of one second at f/8 to create the fluid lines of brilliant, colored light.

The pulse of the city

To photograph city buildings as a living environment, you first need to spend some time walking the streets, observing how the pace of life varies from area to area and from hour to hour. You can then plan a treatment combining architectural and human subjects so that they complement each other.

In the early morning and evening cities become vast thoroughfares for the passage of people to and from work. The atmosphere becomes charged with frenetic activity, and capturing this photographically requires a careful choice of viewpoint and lens. A telephoto lens focused on traffic or a crowd will make streets or sidewalks seem choked, by compressing perspective – a technique used in the picture below at left, in which a composition based on the broad diagonal of the bridge reinforces a sense of purposeful movement.

The mainstream of the city may be busy throughout the day, but in some parts there will be eddies of gentler motion. The photograph on the opposite page at top catches this more subdued mood, and hints at some of the eccentricities of city life as well – the architecture bears a quirky mural, the people are absorbed in their own preoccupations.

Many cities take on a special identity at night. The bright, even colors of neon record well on daylight film and can help to make a powerful image of the jazziness of the city, as in the photograph below.

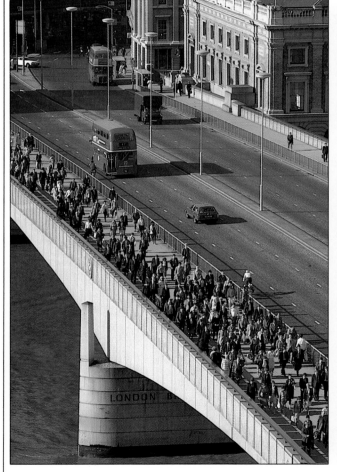

Office workers *throng into London's financial area. By setting up the camera at a high window, the photographer emphasized both the bridge's arched structure and its function as an artery for pedestrians.*

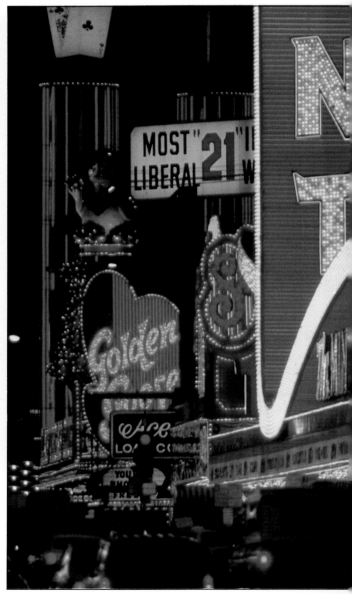

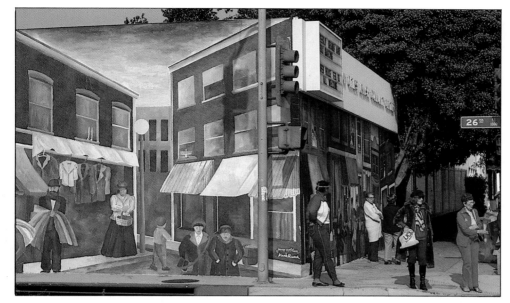

A painted street scene merges into the real street alongside – an illusion that is encouraged by the choice of a head-on viewpoint, which has recorded the wall without distortion.

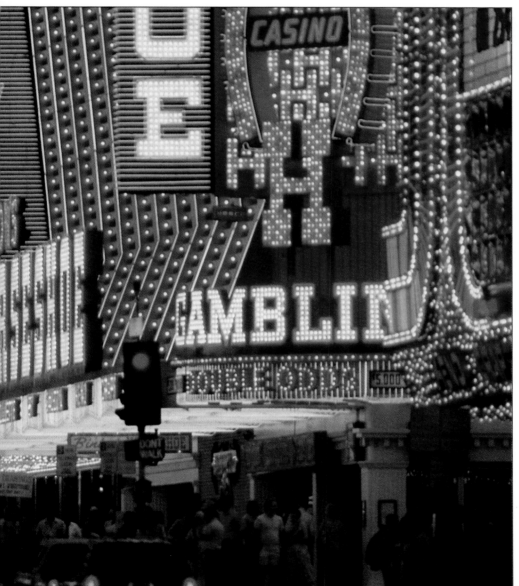

Neon lights transform the appearance of a Las Vegas street. To make the scene look as brash as possible, the photographer used a 300mm lens to compress a long stretch of casinos into the frame. The exposure was 1/30, f/5.6 on ISO 64 film.

Small towns

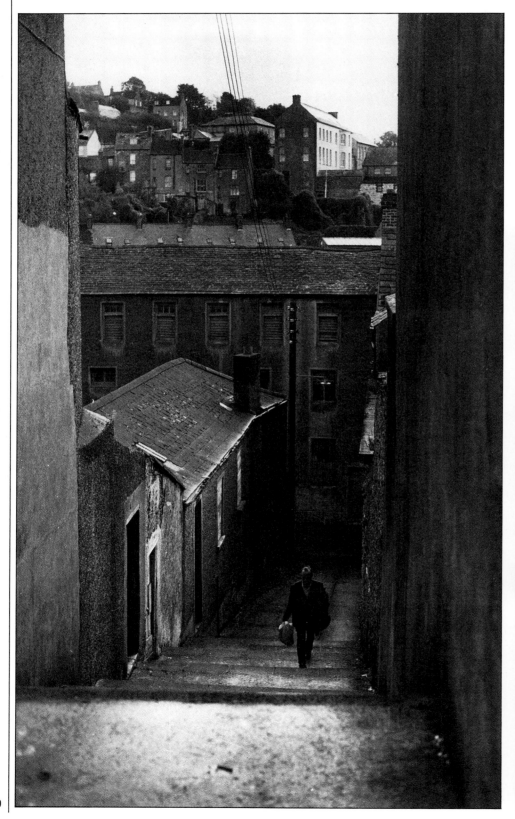

A solitary inhabitant
(left) wends his way home
through the streets of Cork,
Ireland. The view, framed by
the edges of two buildings,
emphasizes the tall, narrow
houses of a hillside town.

A horse and its owner
(below) stop at an ice-cream
parlor in an Australian
suburb. The empty expanses
of foreground and sky help
to evoke a typical Australian
outback scene.

Smaller settlements lack the architectural variety and diverse views found in cities. They offer instead a more distinctive character. While the different parts of a city fuse into one another, small towns tend to be self-contained, and to look inward.

With towns that have a strong flavor of history and tradition – for example, some of the towns in New England dating from the colonial era – conveying character is fairly simple. But in other cases, architectural features may be less important than the general atmosphere of the community, in terms of the way people live and the activities they engage in. Almost always, capturing the personality of small towns involves looking for the human element. The picture opposite is an example. Although camera position and framing bring out the atmosphere of an old Irish town built into a steep hillside, it is the single figure in the otherwise deserted streets that suggests the peaceful, leisurely pace of life characterizing the community.

Every small settlement has one or more meeting places providing the focus for community life: the town square or market place, a church hall or, in more remote places, a bar or general store. The simple one-story building below is just such a place, and its isolated position effectively sums up the character of an Australian outback settlement, even though the town itself is not in view.

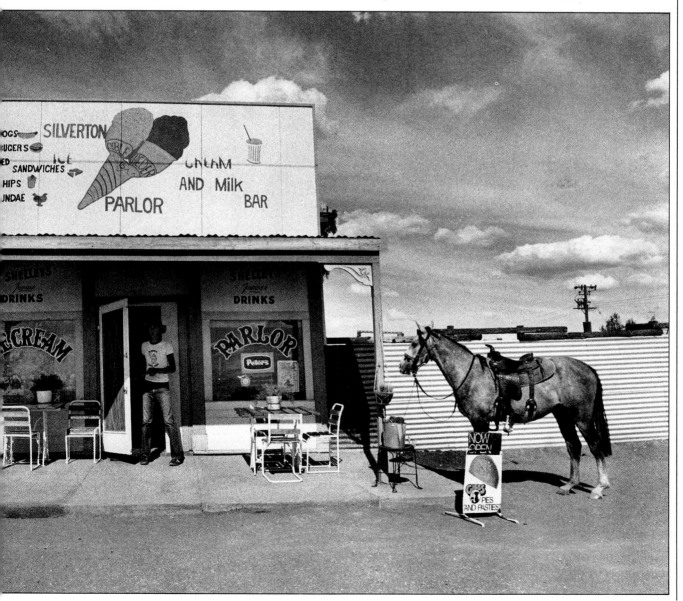

Night lights

Night can transform a town or city into a many-colored paradise of lights. To capture this magic on film is easier than you might expect and requires no special equipment other than a tripod and cable release for exposures of longer than 1/30.

Use daylight film and make the color casts from artificial light sources work for you creatively. Incandescent light will show as a warm orange; fluorescent lights, like those illuminating the high-rise in the panorama of Chicago on the opposite page, will acquire a green cast.

Slow film gives the best results, although it requires longer exposures. Most TTL meters are unreliable at shutter speeds of one second or slower, but exposure settings for illuminated city scenes are less critical than for daytime photography. If you bracket two stops either way, you will often find that more than one result is acceptable.

The added visual interest of moving vehicles is vividly illustrated in the pictures here. A time exposure of several seconds will turn head lights and tail lights into streaks or tubes of color. From a high viewpoint, this technique can sometimes be used to help define the layout of streets.

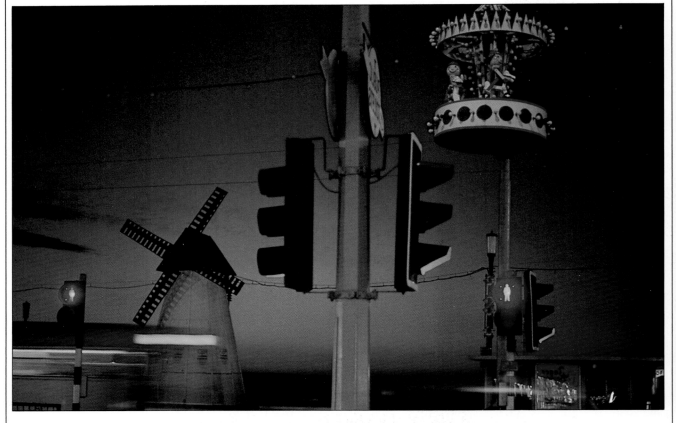

Illuminated amusements (above) at the English seaside town of Blackpool form an incongruous background for functional stoplights. On ISO 200 daylight film, an exposure setting of 1/8, f/4, judged by a TTL meter reading, recorded a moving bus as a phantom streak of light.

Tubes of light (left) mark a car's descent on a hilly street in Berne, Switzerland. The photographer used ISO 64 daylight film and with the aperture set at f/4 opened the shutter for 20 seconds. The long exposure gave an attractive violet hue to the night sky.

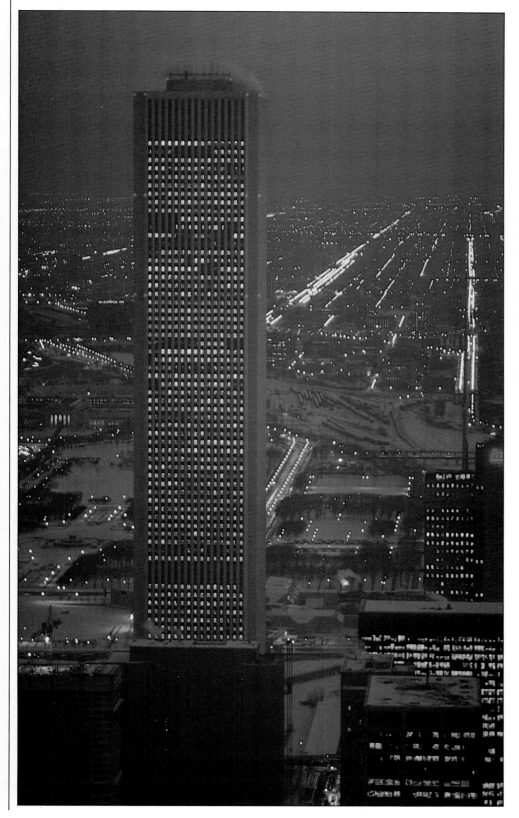

Chicago in winter,
10 minutes after sunset,
resembles a vast lighted
plain, from which the
Standard Oil Building rises
like a giant finger of light.
The photographer used ISO
64 daylight film and judged
the exposure by his TTL
meter at 1/30, f/4.

Villages and rural communities/1

There are places, isolated from the mainstream of life, that evoke the past so strongly they seem to have been frozen in time. These communities require sensitive photographic treatment to convey their historic atmosphere.

Because bright colors and harsh light can easily detract from this type of subject, the restrained, understated quality of black-and-white film is often more suitable. Viewpoint is an important consider-

ation: any historic place is likely to attract tourists, so you may need to move back from the scene to exclude figures. Alternatively, choose a time of day when the streets are temporarily deserted. Imaginative use of foreground framing can also help to control the content of a picture as well as add depth and interest to the composition. The authentic detail of the old wagon wheel on the opposite page at bottom is a good example.

Thatched cottages look directly onto the street in a sleepy English village. A 105 mm lens brought the houses forward to emphasize the intimate, enclosed nature of a traditional community.

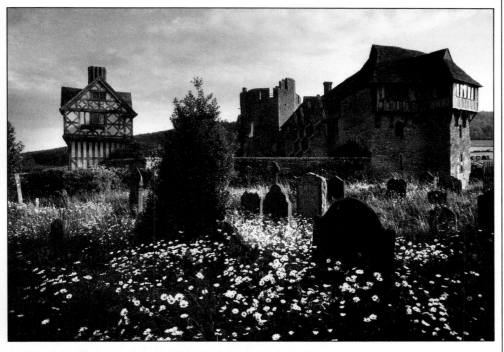

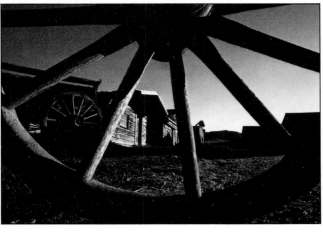

An overgrown graveyard (above) leads the eye back to an old moated manor and Elizabethan gatehouse in Shropshire, England. The evidence of neglect in the setting adds to the sense of a long-forgotten past.

A restored mining town (left) outside Nevada city, Montana, is framed by the spokes of a wagon wheel. The exaggerated perspective of a 28 mm lens suggests the wild, remote location of the town.

Villages and rural communities/2

Some communities have such an intimate relationship with the land that they seem to have grown from it naturally, without human intervention. The best photographs of such places are those that emphasize the close connection between the architecture and the surrounding terrain.

With buildings in a relatively flat landscape, you can create a sense of spaciousness by placing them close to the bottom of the picture with an expanse of sky above – a strategy that succeeds best when there are interesting clouds, as in the photograph below. Another approach is to position the buildings in the middle distance and include a lead-in foreground feature, such as a cart or a bank of flowers. Either keep the whole scene in sharp focus with a wide-angle lens or close in with a telephoto lens, perhaps using any foreground vegetation as a softly focused frame.

The two pictures on the opposite page show differing but equally effective techniques that accentuate the way that villages embed themselves in mountainous terrain. In one, a steep view downward along the spine of the village suggests the rugged location; in the other, a telephoto lens brings forward a misted backdrop that conveys the site's dizzying height.

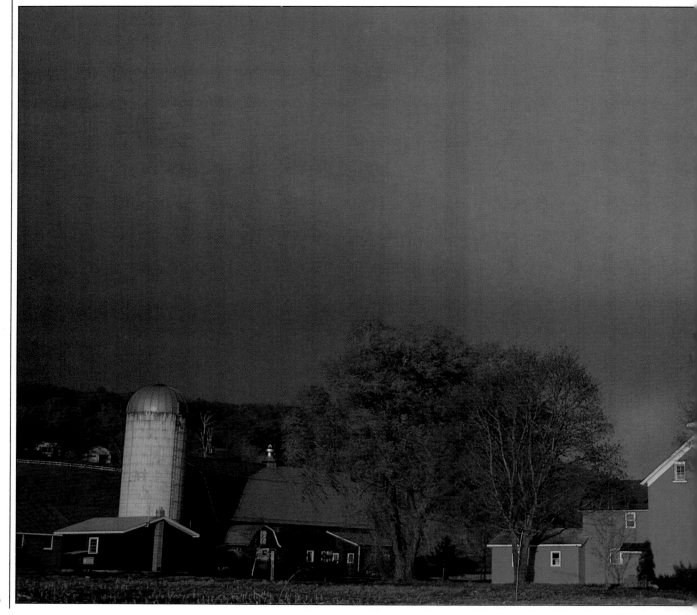

Red tiled roofs lead to
a squat church that forms the
focus of a Venezuelan hill
village. The photographer
aimed down along the axis
of the main street to show
the trio of walking villagers
and to suggest the contour
of the narrow ridge.

Farm buildings (below) in
Columbia County, New York,
appear brightly-lit beneath
dark clouds, which intensify
the trapped autumn sunlight.
The photographer used a
105mm lens from a distant
viewpoint across a field.

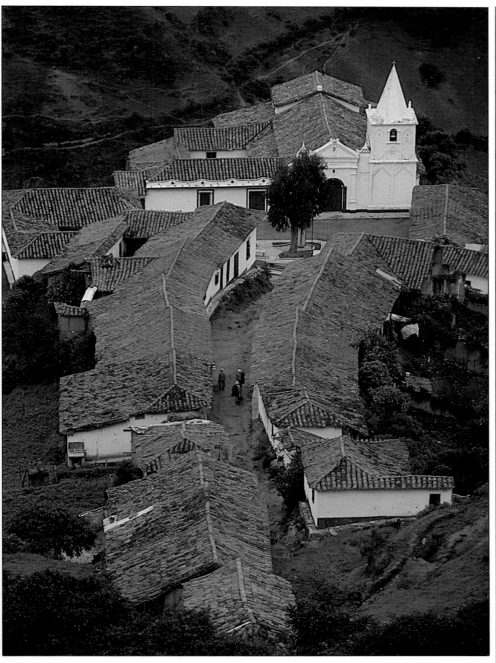

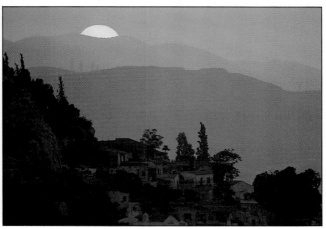

Mountain houses (left)
outside Athens, Greece, seem
carved in stone ridges from
their craggy site. A 400mm
telephoto lens enlarged the
far-off hills and the orb of
the sun sinking behind them,
and contributed to the mood
of the picture by making
the background even hazier
than it was in reality.

The power of industry

To think of industrial architecture as an ugly blot on the landscape is an oversimplification. In fact, industrial structures range in character from an impressive brooding immensity to an airy delicacy that is particularly attractive in silhouette.

When photographing massive industrial buildings, such as blast furnaces, the grainy texture of fast black-and-white film – say, ISO 400, as used in the two larger pictures here – is the perfect medium. Belching smoke or outpourings of steam can add a note of drama. Alternatively, you can mimic this effect by choosing a day when there are spectacular clouds, as in the view of the plant at the bottom of this page. If you get a chance, try photographing an industrial landscape in a storm, when lightning can give a sense of elemental power.

Lighted industrial complexes make interesting subjects for nighttime photography. Use daylight film to bring out the unnatural hues of the mixed lighting, and experiment with long exposures.

Cooling towers of an electric power station rise like man-made volcanoes behind two houses with a wry street sign outside. By using a 200 mm lens to flatten perspective, the photographer made the towers appear threateningly close to the dwellings. The negative showed a broader view of the scene, including surrounding details that contributed little to the impact of the photograph. Enlarging only the central part of the image increased the graininess that resulted from ISO 400 film.

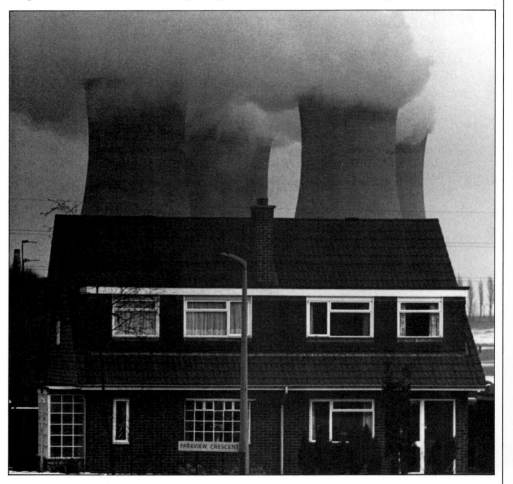

Pipes and tanks of a pet-food processing plant form a busy composition against billowing clouds at midday. Exposure for the bright sky darkened the factory to bring out the complexity of its structure.

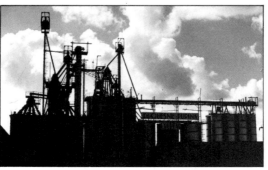

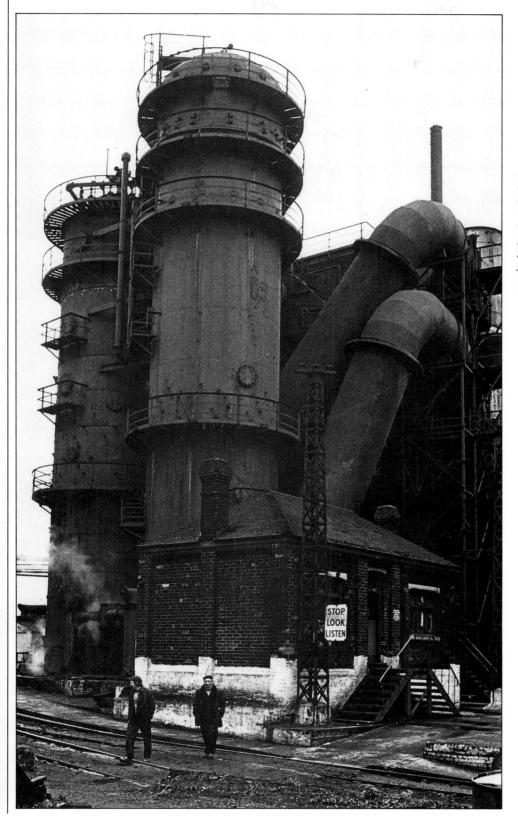

*A **blast furnace** dwarfs a pair of ironworkers who are walking toward the camera. By filling the frame with the structure, the photographer underlined its gargantuan size. The ISO 400 film yielded a grainy texture appropriate to the raw brick and iron-plated surfaces.*

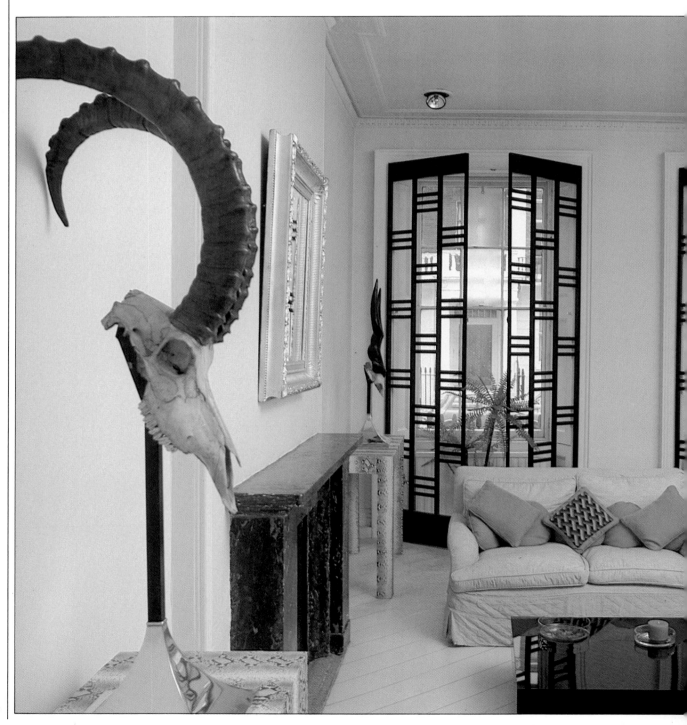

PHOTOGRAPHING INTERIORS

Photographing interiors requires some technical skills. The small scale and limited space mean that you have to give special attention to camera position, angle of view and choice of lens. Compared with daylight outdoors, interior lighting conditions usually present much greater contrasts, often requiring the use of flash or photolamps and reflectors as well as careful judging of exposure.

On the other hand, interiors offer you the chance to exercise complete control over the image. You can light a room almost as you would a still-life to create a specific mood and to reveal the intensely personal relationship between an interior and the people who live or work in it. The very limitations of space can work to your advantage. Because any viewpoint necessarily excludes part of a room, you can focus on the strongest features, for example the decorative screens in the picture at left. The section that follows stresses the importance of arranging all the elements in the viewfinder without producing a stilted effect. And it shows you how to balance a tricky mixture of lighting to achieve natural-looking results.

The living room of an interior designer reveals total harmony of pattern and color. Two strong photolamps, their bulbs covered with blue color-conversion filters, bounced light from the pale walls behind the camera and thus balanced the levels of light inside and out.

Camera position

The first decision when photographing an interior is where to set up the camera. Sometimes the layout of the room will dictate this, but usually it is possible to take pictures from a number of different spots, as demonstrated by the five pictures here, all taken in the same room. You will probably need to photograph a room from at least two angles to get a comprehensive record. In a small room, you may have to position the camera in a corner to get a reasonable view. Look first for a feature – a window or an ornate fireplace – that will provide a strong focus. Then look at the room through the camera so that you can visualize how the scene will appear on film, particularly if you are using a wide-angle lens. Look especially carefully at the edges of the viewfinder, and move any pieces of furniture that are only halfway in the picture: a chair with its legs disappearing from view looks very disconcerting. One exception is a horizontal surface, such as a coffee table in the foreground, which can lead the eye into the picture.

A camera tends to emphasize clutter and dust, so clear away any irrelevant knickknacks and wipe all surfaces. Straighten pictures and mirrors, making sure that their glass does not reflect the camera or light. You may be able to eliminate an unwanted reflection by lifting one side of the mirror frame away from the wall with a small object, such as a 35mm film package. Alternatively, spray the glass with a fine film of water.

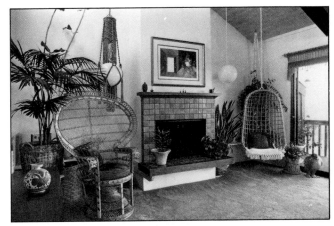

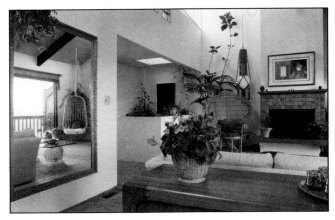

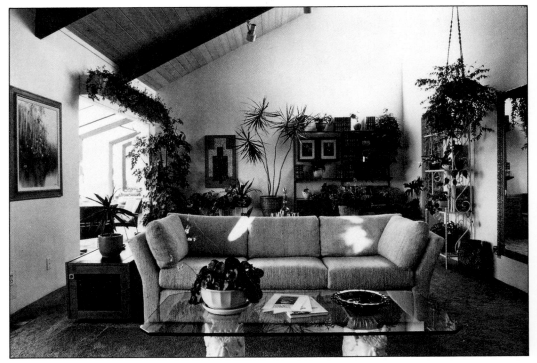

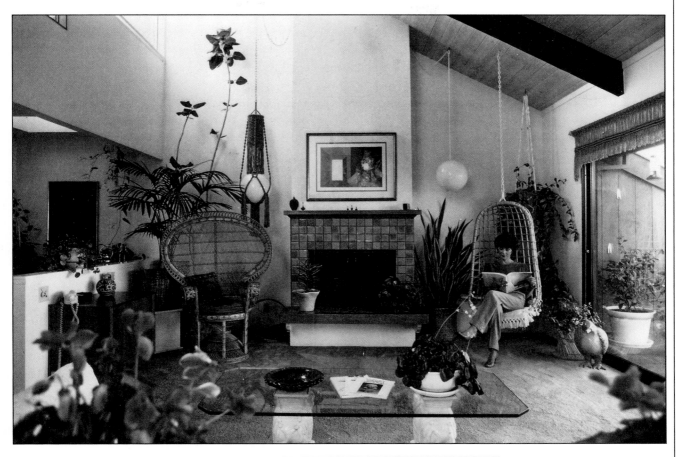

Five views of a sunlit room
show how moving the camera can change
the sense of space and atmosphere. The
first photograph (top left) makes
the room look small and eccentrically
furnished. Moving back and including
a mirror (middle left) quickly dispels
this impression. For the third view (at
left), the photographer positioned the
camera by the fireplace, looking back
at the far wall. This viewpoint made
maximum use of the brilliant sunshine,
and included the glazed sun deck
outside. Perhaps the most successful
picture is the frontal view facing the
fireplace (above). This gives a true
feeling of spaciousness, while the plants
and possessions make the room look
lived in, and the figure enhances this.
A close-up of pictures and shelves
(right) provides details of the room
as an alternative to a broad view.

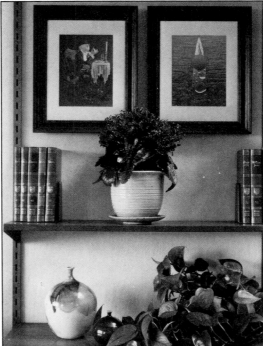

Working in a small space

If you try to photograph an interior with a 50mm normal lens, usually you will find it impossible to step back far enough for a broad view. Sometimes you may be able to position yourself in a neighboring room and aim the camera through a connecting door or archway. Or you may extend the field of view by photographing at an oblique angle into a large mirror. But if neither of these options is available, you will have to be content with limited views or use a lens of a shorter focal length.

The pictures on the opposite page compare the effects of using a 50mm, 35mm, 28mm and 20mm lens for different views of the same room from the same camera position. The shorter the focal length, the more comprehensive the view. However, wide-angle lenses also give more image distortion at the edges, and especially at the corners, of the frame. This effect is all the more obvious in interiors because so much of the scene is close to the camera, and the nearer the subject the more the distortion. Bearing this in mind, compose foregrounds with care; objects of regular shape in the corner of a picture, such as a round clock, will look misshapen, whereas a houseplant may look perfectly normal.

When using a wide-angle lens, remember that even a slight upward or downward tilt of the camera will make the vertical lines in the scene converge or diverge unsettlingly. By deliberately angling the camera steeply, however, you can sometimes exploit this effect as in the composition below.

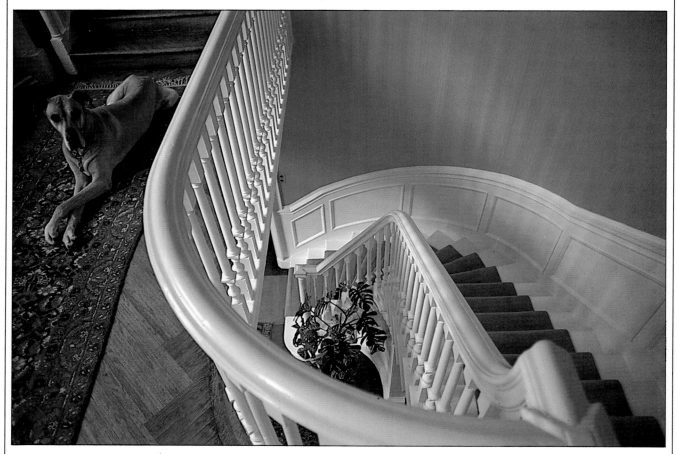

A staircase, photographed from above with a 28 mm lens, acquires an elegant form reminiscent of a whorled seashell. The combination of a wide-angle lens and a tilted camera makes the banisters seem to lean outward, and the neat balancing of the Great Dane and the plant strengthens the composition and the sense of depth.

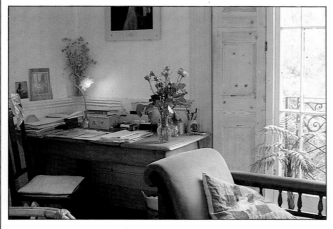

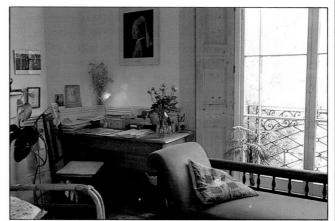

1 – Details in one corner of a relatively small living room convey something of the room's character, but the relatively narrow field of a 50mm lens (diagrammed at right) shows us little of the room as a whole. To get the broadest possible view in the restricted space available, the photographer stood in the opposite corner.

2 – A broader view opened up when the photographer changed to a 35mm lens. However, the enlarged area of view is still not enough to add much of interest to our knowledge of the room. Note that neither the armchair nor the couch was close enough to the camera for distortion to occur in the image.

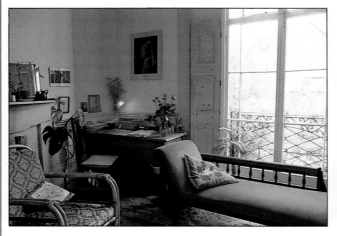

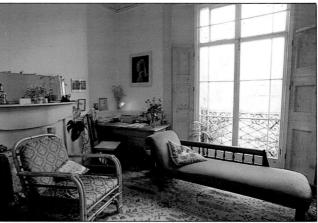

3 – Half the width of the living room came into the field of view when the photographer used a 28mm lens. With the change to a lens of shorter focal length, stretching of the image is apparent at the corners of the picture. In particular, the couch seems to bulge at the point where the frame crops it.

4 – An informative view of the room's decor was achieved by switching to a 20mm lens with a much wider angle. However, note the increased evidence of image distortion at the corners. The couch now looks distinctly out of proportion as the extended perspective makes its shape taper oddly.

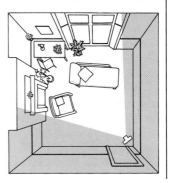

Daylit rooms

The simplest and usually the most attractive way to light interiors is by natural light alone. With no additional lighting, calculating exposure is relatively straightforward provided you can overcome the problem of high contrast.

When direct sun shines into a room, the brightness range between the sunlit and shadowed areas is far greater than the latitude of the film can record. Thus, strong direct sunlight is generally unsuitable for interior photography. If you do not want to wait until the light changes, diffuse the sun's rays by hanging a white sheet or some tracing paper across the outside of the window. However, look out for opportunities to use direct sun for dramatic effect or to highlight an interesting detail within a scene, as demonstrated in the picture at far right.

Even when the light entering a room is diffused, some problems of contrast will arise because of the fall-off of light between the windows and the opposite side of the room. Placing a reflector made of aluminum foil pasted to cardboard on the dark side of the room facing the window will lighten shadowed areas. If the light is coming from more than one side, base the exposure on an area of medium shadow to achieve the kind of even tones recorded in the picture of a grand living room below.

Look too for views that lessen the effect of high contrast. In the picture at near right, light from several directions reflecting off white surfaces gave even lighting with soft shadows.

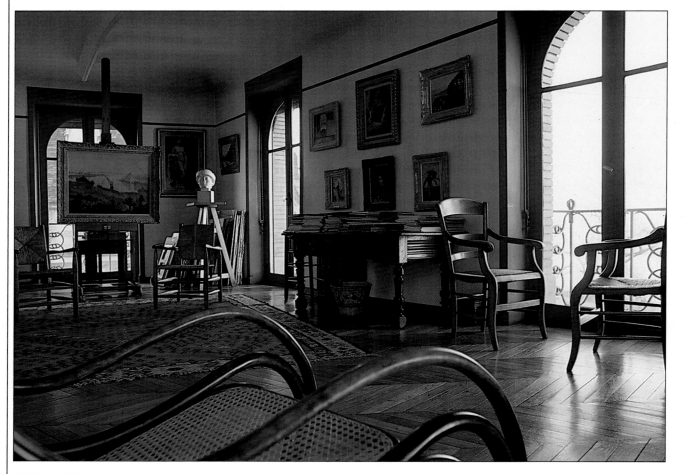

Diffused light from an overcast sky enhances the mood of restful elegance in a spacious living room. The photographer took his reading from the wall above the table to get correct exposure in most of the room – 1/15 at f/8 on ISO 64 film. The areas around the large windows, however, were slightly overexposed.

Daylight through windows and arches (left) suffused the whitewashed walls and wood of a charmingly simple interior. The photographer allowed one stop above the meter reading of 1/60 at f/11 in order to retain the crisp, pristine quality of the scene.

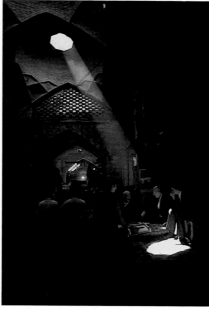

A beam of bright sunlight (above) through a domed roof pierces the gloom of a Middle Eastern bazaar to spotlight a lively aspect of the scene. Contrast was too high to record both the beam and the surroundings correctly; so the photographer exposed for the figures at 1/15, f/2.8 on ISO 200 film, and allowed the brilliant pool of light to lose detail.

Supplementing daylight

When there is insufficient daylight to light an interior evenly, you will need to use extra artifical lighting to fill in shadows and reduce overall contrast. The aim of this supplementary lighting is to enhance, not compete with, the main light coming through the windows. This way the effect will look completely natural. Portable electronic flash has the advantage of being approximately the same color as daylight. However, fill-in lighting also needs to be soft and shadowless. Flash is reliable and convenient to carry, but at full output it will give a harsh, unnatural effect, as in the photograph immediately below. For fill-in lighting, the output should be about half or a quarter of the normal setting. Often, you can reduce the output simply by setting the flash

unit for a faster film than the kind you are using. Alternatively, reduce the aperture setting by one or two stops and set a slower shutter speed to avoid underexposing the areas lit mainly by the daylight.

One problem with direct flash is that because the light source is so small, it can cause pinpoint reflections from shiny surfaces and can also cast sharp hard-edged shadows. To avoid this, bounce the flash off pale room surfaces or a piece of white cardboard. If you do use direct flash, make sure that the daylight is considerably stronger than light from the flash, as in the picture opposite. Whether bounced or direct, flash will give more balanced lighting if you position it off the camera, using a stand, clamp mount or table for support.

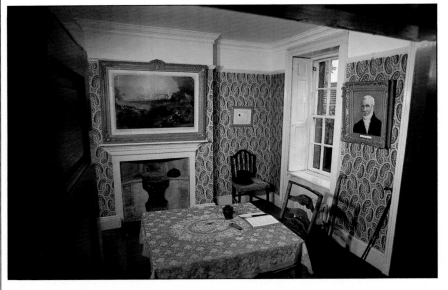

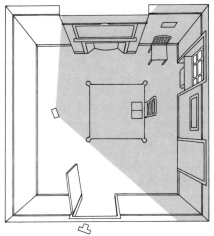

Using flash as fill-in lighting
The two views (left) of a reconstructed Victorian parlor demonstrate the importance of balancing supplementary flash lighting and daylight. A portable flash unit was set up in the room, opposite the window, with the camera positioned in the doorway (diagram, above). The exposure setting on the camera was the same for both pictures – 1/60, f/11 on ISO 64 film. In the top picture, the flash, set at full exposure, overwhelmed the daylight, resulting in hard, flat light and unnatural shadows. For the softer picture at left, the output of the flash was cut to half – by setting the flash unit at double the film speed – so that it lightened the shadows but left the sunlight as the main lighting source.

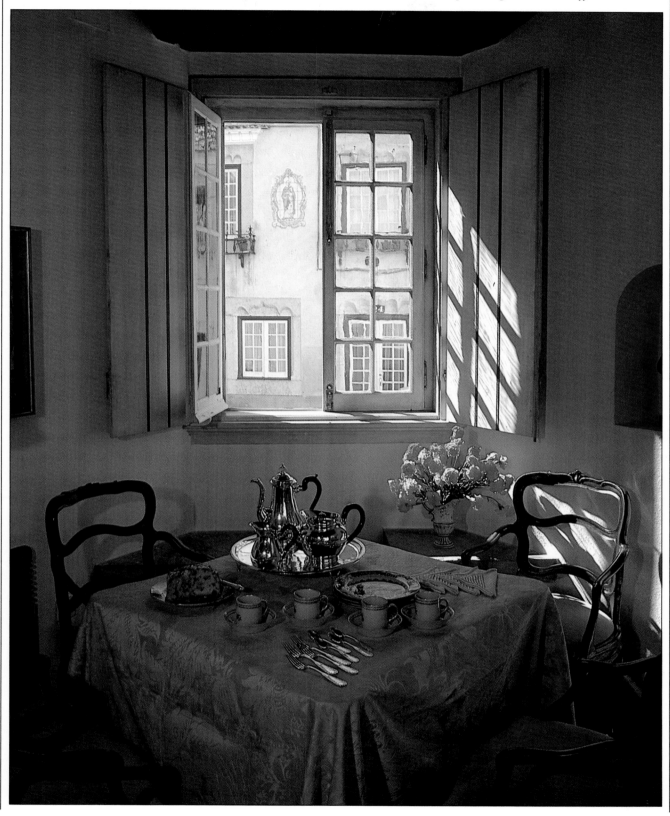

Slanting sunlight casts shadow patterns in a dining room. A flash unit held to one side of the camera and set at double the film speed of ISO 64 reduced the high contrast without producing an unnatural effect.

Indoor lights

Nighttime can dramatically change the appearance of an interior. After dark, windows cease to be the main source of light, and indoor lights dominate the scene. As the lighting changes, you need to change your photographic technique accordingly. If you are using daylight film, you should use a No. 80A and a No. 82B blue filter over the lens to counteract the yellow hue. Alternatively, load the camera with film balanced for tungsten light and use a No. 82B filter.

Although room lights on their own may provide sufficient lighting, they cast patterns of light and shade that are often too stark to produce a natural picture. To remedy this, you can supplement table and ceiling lights with tungsten photolamps, such as the one shown in the box at far right.

Where you place these lamps depends very much on the layout of the room. If there are alcoves or odd corners, as in the room below, you can use these to conceal the lamps and their stands.

Try to avoid shining a floodlight directly into a room. Instead, diffuse the beam by reflecting it from a pale wall or ceiling or from a large piece of white cardboard. Do not put the light too near the reflecting surface or heat from the bulb may cause scorching. This technique of bouncing light provides natural-looking fill-in lighting without overpowering the ordinary room light, as the picture on the opposite page shows.

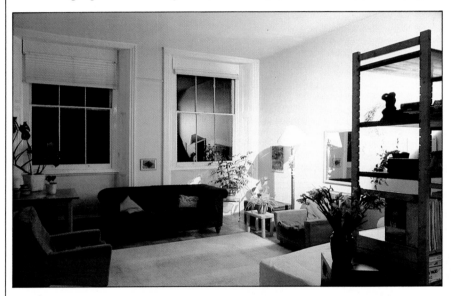

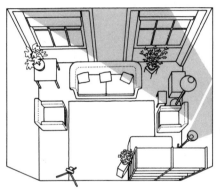

1 – Unbalanced lighting mars this picture of a living room. To boost the light from the table lamp, the photographer used only one floodlight, reflected from the white wall behind the shelf unit, as diagrammed above.

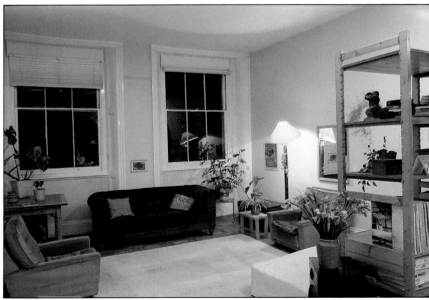

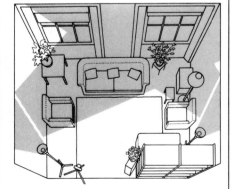

2 – Uniform lighting was achieved with the aid of a second floodlight. Placed to one side of the camera, as shown above, it was angled to throw light onto the left-hand wall.

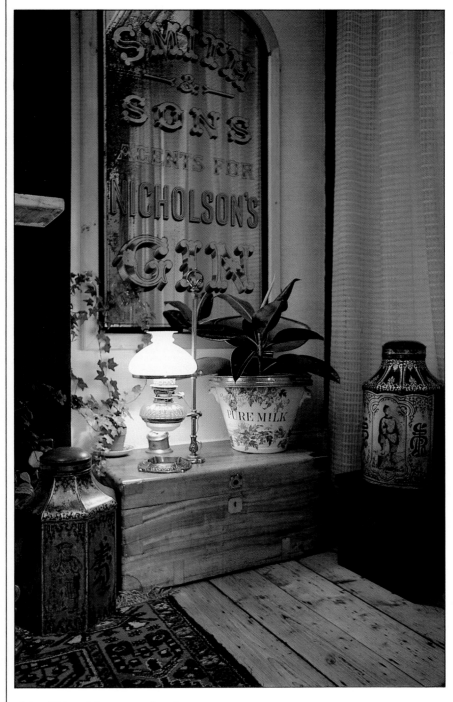

A traditional kerosene lamp appears to light this corner of a room, but in reality most of the lighting for the picture came from a powerful floodlight directed at the white ceiling. Using ISO 160 tungsten-balanced film, the exposure was 1/15 at f/8.

Photographic lighting
A tungsten photolamp, such as the 800-watt model shown here, is a compact, convenient light source for photographing interiors. Turning a ring at the back of the head changes the beam from a broad floodlight to a narrow spot, and the lightweight stand can elevate the lamp to a height of eight or nine feet.

Mixed lighting

Tungsten light has a distinct orange tint when compared with natural daylight. As a result, if you use daylight film to photograph a room lit partly from a window and partly by household tungsten lamps, the areas lit mainly by the lamps will appear washed with unnatural hues. To prevent the film from picking up differences of hue, you must take steps to balance the colors of the two light sources.

The simplest way to do this is to replace the household bulbs with blue-tinted bulbs. The decorative "daylight blue" variety sold by electrical retailers gives a reasonable approximation of the color of light from a window, as the second picture in the sequence below shows.

A different approach is to use regular bulbs, a No. 82B blue filter and film balanced for tungsten light. This technique will record correctly the areas of the room lit by tungsten light, but windows and

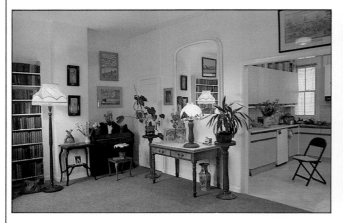

1 – **The yellowish tint** that washes the kitchen and the upper walls of the living room comes from tungsten bulbs recorded on daylight-balanced film. The only areas that appear in natural hues are the window, and the floor at the left of the picture, which is lit by daylight from behind the camera.

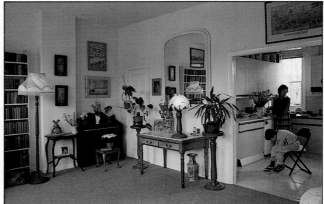

2 – **Lifelike color** returns to the scene when blue bulbs take the place of ordinary light bulbs. But because the colored bulbs are dimmer than the untinted bulbs, the photographer gave extra exposure, with the result that the kitchen window area appears bleached out (overexposed).

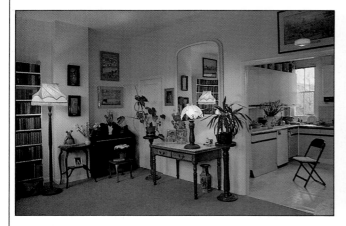

3 – **A blue tint** spoils the picture when the scene is photographed with film balanced for tungsten light. This shows natural hues in areas illuminated by the room lights but intensifies the blue of the daylight. Covering the windows with orange plastic would have helped to correct this effect.

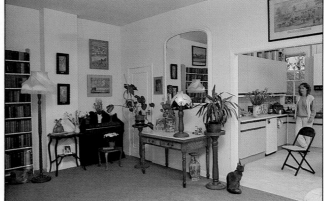

4 – **The perfect balance** of color and brightness shown here is the result of using daylight film with additional lighting – a powerful flash unit directed at the wall behind the camera. This not only lit the room evenly but also brightly enough to allow a small aperture, so the window was correctly exposed.

areas lit by daylight will appear blue in color, as in picture 3 on the opposite page. To eliminate this cold effect, cover the windows with special orange plastic sheeting, as shown below at left.

Rather than balancing the colors of two different light sources, you may instead choose to use daylight film and add enough supplementary lighting to overpower the warm glow of the tungsten lamps, as in picture 4 on the left-hand page and the larger picture below. To take these views, the photographer used electronic flash. But you could equally well use photographic tungsten lights provided you cover them with No. 80A blue filters to match the daylight from the window. Alternatively, if you want to exploit the various colors of mixed unbalanced light sources for creative effect, try using a fast color negative film such as Kodacolor VR 1000, omit using filters, and bracket your shots.

Filtering daylight
Sheets of transparent orange plastic placed across windows as shown above will act as filters to warm the color of daylight. This technique is useful when you want to photograph an interior with film balanced for the tungsten room lights. If the windows appear in the picture, tape or staple the plastic to the outside to make any wrinkles less evident. Rolls and sheets of this material – which is the same color as that of a No. 85B filter – are available from companies that supply equipment for making motion pictures.

Polished floor tiles reflect both the warmth of a hanging lamp and the natural daylight from outdoors. By placing a portable flash unit so that it lit the bricks near the lamp, the photographer prevented the interior from taking on the characteristic orange cast of tungsten light, yet retained the cosy atmosphere. Using daylight-balanced film, he made an exposure of 1/60 at f/8.

The human touch

Looking at a picture of an unoccupied room containing signs of recent use, we often have a definite impression that someone is near. All three photographs here encourage this feeling by hinting at a simple, human narrative.

A bold, uncluttered composition is usually necessary if you wish to make the most of telltale human touches in an interior. In the picture below, a simple head-on viewpoint focuses attention on the jeans, and the framing is close enough to exclude irrele-

vant details without losing a sense of the room's character. By exposing for highlights in the photograph of a rumpled bed on the opposite page, the photographer exploited the morning light to aid him in a similarly selective approach.

If you contrive human touches instead of simply discovering them, the result may look stilted. To avoid this danger in the lower view on the opposite page, the photographer enticed a cat into the scene for a dash of spontaneity.

Denim jeans hang over a chairback in front of their owner's bureau in a farmhouse room. Exposing for the desk, at 1/60, f/11 on ISO 64 film, bleached the exterior. The only adjustment the photographer made to the scene was to open one window to add movement to the composition. The car outside and the glimpse of more clothes in a wall mirror gave a sense of depth.

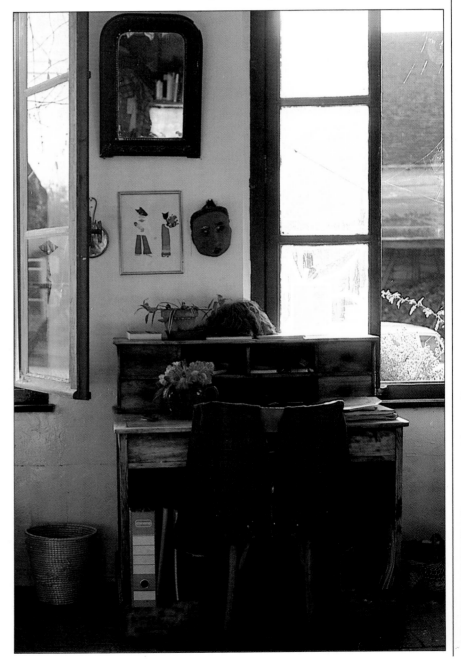

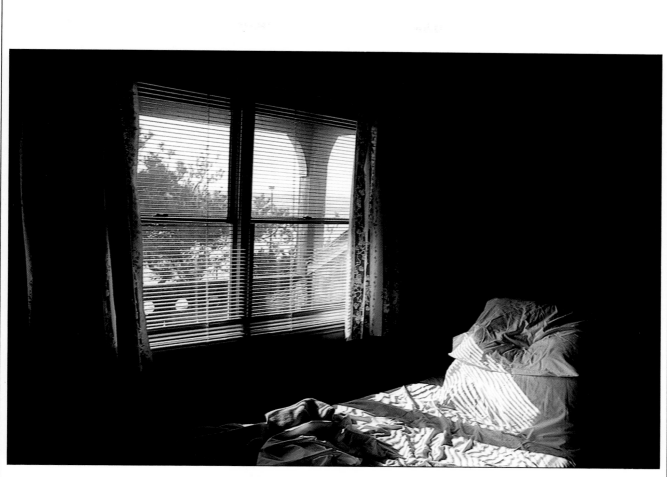

Venetian blinds (above) in the morning sunlight cast striped shadows onto an unmade bed. An exposure set for the highlights – 1/30, f/8 on Kodachrome film – deepened the shadows and defined the creases in the sheet and pillows, strengthening the impression that someone had recently been lying there.

A cat (right) laps eagerly at a bowl of milk, getting a head start on the human breakfasters who have yet to take up their seats at the table. Having arranged the breakfast things, the photographer put the bowl on the terrace, placing it carefully so as to draw the cat to a position where it would become the focal point of the picture. Using ISO 64 film, he set an exposure of 1/125, f/11.

Churches and large interiors

Churches and many other public buildings give architects rein to express themselves on a grand scale, often in complex patterns of soaring arches and sweeping galleries. But for the photographer, large spaces and decorative flourishes create problems. For while the eye can pick out every detail of a finely carved church, the camera may record only gloomy corners and pools of light.

If you can get permission to use a tripod and artificial light, you will be able to cut down such contrasts. One way to do this in dimly lit buildings is to fire several flashes using the technique called painting with light, diagrammed below. Choose a small aperture and set an exposure time to suit the most brightly lit surfaces. Then leave the camera on the tripod with the shutter open and move swiftly around the area firing flashes into the shadows.

In many buildings, tripod and flash are forbidden, so you will have to set your camera's shutter to a speed that you can handhold. Even with fast film and wide apertures, darker corners may appear inky black at a shutter speed of 1/30. However, you can compose striking pictures around brightly lit areas of the interior, as at right.

Longer exposures are possible if you can improvise a support by resting the camera on a solid horizontal surface, such as the parapet in the picture at lower right. Use a cable release to avoid jarring, and bracket the pictures to compensate for the reduced accuracy of the camera's meter in low light.

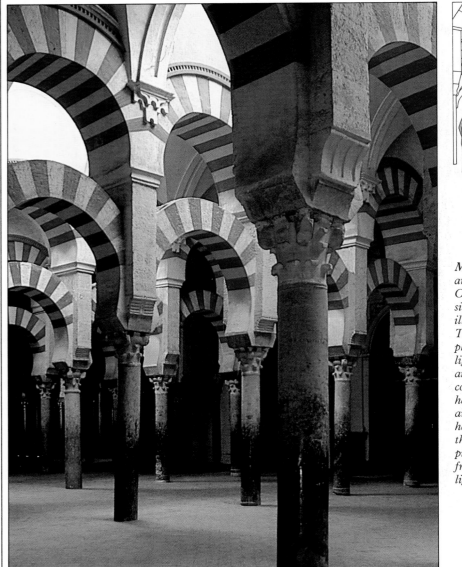

Marble pillars and striped, colored arches crowd the Great Mosque in Córdoba, Spain (left). The light of a single flash would have been too weak to illuminate every corner of the vast hall. Thus, as shown in the diagram above, the photographer painted the mosque with light. He put the camera on a tripod and set the lens to f/22. Then, in the course of an exposure lasting one minute, he fired the flash six times, walking around the hall between flashes. Because he kept moving and wore dark clothes, the photographer did not appear in the picture. And because the flashes came from several different points, the lighting seems completely natural.

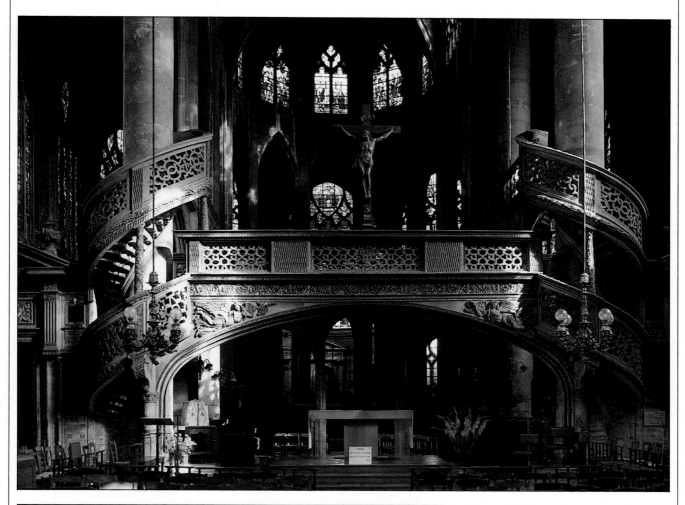

A carved chancel screen catches the light in this view of St. Etienne du Mont in Paris. The photographer took a meter reading from the screen and from the dark area beyond, and realized that the difference in brightness between the two far exceeded the exposure latitude of his film. He set an exposure of 1/30 at f/4 to suit the sunlit screen – the feature for which the church is famous.

Galleries in the Rufino Tamayo Museum in Mexico City were lit less brightly than the main concourse, washed with strong sunlight. With ISO 160 tungsten-balanced film, a meter reading from the gallery walls indicated an exposure setting of 1/4 at f/4, so the photographer steadied the camera by resting it on the foreground parapet.

Photographing stained glass

Ecclesiastical stained glass is one of the most gloriously photogenic of all forms of architectural embellishment. On a humbler scale, in domestic, civic and hotel buildings, stained-glass panels such as the one shown in close-up at the bottom of this page often have a richness of color and boldness of design that make them ideal subjects for the camera.

When photographing stained glass, avoid converging verticals by keeping the camera level if possible. Windows in churches are generally too high for this, but you may be able to use a telephoto lens from a distance to give a shallower angle of view. For the picture on the opposite page, the photographer was able to aim horizontally from a gallery at the other end of the nave, using a long lens. In secular buildings, staircases will sometimes offer a face-on viewpoint, as in the picture below.

Lighting is also critical in stained-glass studies. An overcast day is best because it gives soft, even backlighting that enriches the colors. It also reduces the silhouetting of protective grilles behind windows. Although clouds can add a slight coldness to a picture, you can correct this by using a straw-colored filter, such as a No. 81B.

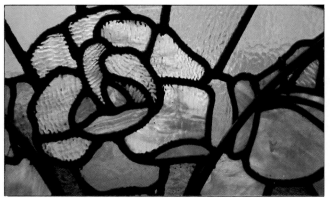

A vast flower of bronze-colored metal (above) fills the ceiling of an office building foyer in Los Angeles, while the stained-glass frontage offers an intriguing glimpse of the scene beyond. A stairway gave a perfect camera position for a view with a 28mm wide-angle lens. Using ISO 64 film and an exposure of 1/60, f/8, the photographer supplemented daylight with fill-in flash aimed at the ceiling.

A rose of stained glass (left), viewed in close-up with a 50mm lens, offers subtleties of hue and texture within a plainly defined pattern. The panel was set in an interior door, and the photographer lit it from behind with a single tungsten photolamp diffused by a tracing-paper screen behind the glass. Using ISO 50 tungsten-balanced film he set the exposure at 1/15, f/8.

A Gothic arch frames
the magnificent 13th-century
rose window at the west end
of the great nave of Reims
Cathedral in France. For a
directly horizontal view, the
photographer used a 200mm
telephoto lens from a high
gallery 150 yards away at the
east end of the church. He
used ISO 200 film and set the
exposure at 1/60, f/5.6.

Looking out

One variation on straightforward interior photography is to combine inside and outside views, using windows or doorways as framing devices.

The trickiest aspect of such combined-view compositions is the high level of contrast. On a bright, sunny day, a typical living room may be seven or more stops darker than the scene outside. The simplest way to balance the light is to wait for daylight to reach an appropriate level. For the larger picture on the opposite page, diffused sunlight gave even illumination to the bay area of the room. For most interiors, however, dusk is the best time to take pictures if you want to retain good detail inside and out. Twilight colors also make a contrast with the warmth of lit interiors, as in the view below.

An alternative to balancing different lighting levels is to sacrifice detail in the view in favor of graphic contrasts. In the picture opposite, for example, the dark interior concentrates interest on bold shapes with accents of color and texture.

A Spanish-style courtyard at dusk intriguingly combines interior and exterior views, taken with a 35 mm lens set at 1/8, f/11. The photographer used tungsten film to record the warm room lighting correctly, while increasing the cool blue cast of the early evening light.

A saloon doorway is cleanly silhouetted against brilliant sunlight. The highlighted areas of brick, floorboards and curtains provide texture and pattern in the picture.

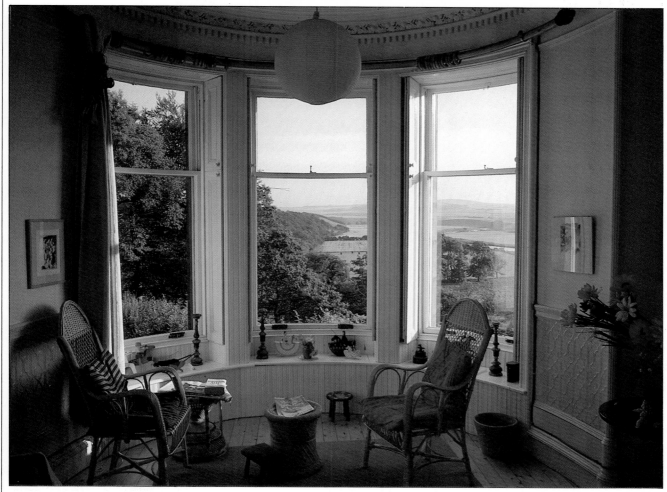

Sunlight dapples a bowfront sitting room which looks out over miles of open countryside. The angle of the windows and the oblique, soft light gave sufficiently balanced lighting inside and out. ISO 64 film at 1/60, f/11 caught the subtle hues.

Glossary

Accessory shoe
A fitting on top of a camera that accommodates a flash unit. It makes contact between the flash unit and the shutter circuit to provide flash synchronization. The term "hot shoe" is sometimes used as an alternative.

Aperture
The opening in a lens diaphragm that admits light. Except in very simple cameras, the size of the aperture can be varied to regulate the amount of light passing through the lens to the film.

Artificial light
Any light used in photography that is not from a natural source. The expression generally refers to light specifically set up by the photographer, such as flash or photolamps. Some of these forms of artificial illumination (for example, blue flashbulbs and electronic flash units) approximately duplicate the color temperature of daylight and can be used with daylight-type color film without filtration.

Bracketing
A way to ensure accurate exposure by taking several pictures of the same subject at slightly different exposure settings above and below the presumed correct setting. It is particularly useful in tricky lighting situations.

Cable release
A thin cable encased in a flexible plastic or metal tube, used to release the shutter when the camera is not being handheld. The cable release helps to avoid vibration when the camera is mounted on a tripod or set on a steadying surface for a long exposure.

Cropping
Trimming an image along one or more of its edges to eliminate unnecessary parts, or framing a scene to leave out parts of the subject.

Depth of field
The zone of acceptable sharp focus in a photograph, extending in front of and behind the plane of the subject that is most precisely focused by the lens. You can control or exploit the depth of field by varying three factors: the size of the aperture, the distance of the camera from the subject, and the focal length of the lens. Decreasing the size of the aperture increases the depth of field; if you focus on a distant subject, depth of field will be greater than if you focus on a near subject; and a wide-angle lens gives greater depth of field than a normal lens viewing the same scene.

Diaphragm
The part of the camera that governs the size of the aperture. The most common type is the iris diaphragm – a system of overlapping blades that form a roughly circular opening that is variable in size and similar in principle to the iris of the human eye.

Exposure
The total amount of light allowed to pass through a lens to the film, as controlled by both aperture size and shutter speed. The exposure selected must be tailored to the film's sensitivity to light, indicated by the film speed rating. Hence, overexposure means that too much light has created a slide or print that is too pale. Underexposure means that too little light has resulted in a dark image.

Fill-in flash
Flash used to supplement the principal light source and brighten dark shadows.

Film speed
A film's sensitivity to light, rated numerically so that it can be matched to the camera's exposure controls. The two most commonly used scales, ASA (American Standards Association) and DIN (Deutsche Industrie Norm), are now superseded by the new system known as ISO (International Standards Organization). ASA 100 (21° DIN) is now expressed as ISO 100/21°, or ISO 100.

Filter
A thin sheet of glass, plastic or gelatin placed in front of the camera's lens to control or change the appearance of a picture, for example by altering color.

Fisheye lens
An extremely wide-angle lens, having an angle of coverage of approximately 180°. Such lenses produce highly distorted circular images, which in all but the widest angle fisheyes are cropped to a rectangle by the film format. The area in the center of the image is greatly enlarged, and the whole effect is similar to that produced by a convex mirror.

Flare
Non-image-forming light reflected inside the camera or between the elements in the lens, producing irregular marks on negatives or producing unwanted overall exposure.

Flash
A very brief but intense burst of artificial light, used in photography as a supplement or alternative to any existing light in a scene. Batteries supply the power for most flash units.

Format
The size or shape of a negative, slide or print. The term usually refers to a particular film size (for example, 35mm format), but can mean simply whether a picture is upright (vertical format) or left-to-right (horizontal format).

Keystoning
Perspective distortion most commonly encountered in architectural photography. The keystone effect, which is caused by camera tilt, changes parallel verticals in the subject to converging verticals in the image. The solution is to keep the camera horizontal and, if necessary, to use a perspective control lens.

Lens hood
A simple lens accessory, usually made of rubber or light metal, used to control flare by shielding the lens from light coming from outside the field of view.

Neutral density filter
A gray filter that reduces the amount of light forming an image without altering its color content.

Panoramic camera
A special camera with a lens that moves through an arc during exposure to cover a broad area on a long stretch of film.

Perspective control lens
Also known as a shift lens, a perspective control lens can move both laterally and vertically and is used chiefly in architectural photography to include, say, the top of a building without having to tilt the camera and cause perspective distortion.

Polarizing filter
A filter that can change the vibration pattern of the light passing through it, used chiefly to remove unwanted reflections or to darken the blue of a sky.

Shift lens see PERSPECTIVE CONTROL LENS

Spot meter
A special type of light meter that can take a reading from a very narrow angle of view, so that it measures a small subject area at a considerable distance.

TTL
An abbreviation for "through the lens," generally used to refer to exposure metering systems in which the light intensity is measured after passing through the camera lens.

Tungsten light
Light sources that use a tungsten filament. The light produced is redder in tone than flash or daylight unless recorded on tungsten-balanced film or with correction filters.

Index

Page numbers in *italic* refer to the illustrations and their captions.

Acknowledgments

Picture Credits
Abbreviations used are: t top; c center; b bottom; l left; r right.
Other abbreviations: MF for Michael Freeman, IB for Image Bank and
SGA for Susan Griggs Agency. All Magnum pictures are from The John
Hillelson Agency.

Cover Ernst Haas/Magnum

Title Uli Butz. **7** Pete Turner/IB. **8-9** David Whyte. **10** Graeme Harris.
10-11 Harold Sund/IB. **12-13** Adam Woolfitt/SGA. **14** R. Gunther/
Explorer. **15** Larry Dale Gordon/IB. **16-17** Chuck Kuhn/IB. **18-19** John
Heseltine. **19** all Ian Bradshaw. **20** Gill C. Kenny/IB. **21** t MF, cl
Michael/IB, cr De Lory, bl Luis Villota, br De Lory. **22** Robin Laurance.
23 Nancy Durrell-McKenna. **24** John Sims. **25** tl Adam Woolfitt/SGA, tr
Robin Laurance, b Graeme Harris. **26-27** Richard Haughton. **27** t Erwin
Kneidinger, b John Garrett. **28** Uli Butz. **29** t Nadia MacKenzie, bl Uli
Butz, br MF. **30-31** Robert Frerck/Click/Chicago. **31** Al Satterwhite/IB.
32 t Trevor Wood, b Pete Turner/IB. **32-33** Erik L. Simmons/IB. **33**
Adam Woolfitt/SGA. **34-35** John Freeman. **36** John Sims. **37** John P.
Kelly/IB. **38** Richard Haughton. **39** Richard & M. Magruder/IB. **40** l
Angelo Hornak, r MF. **41** MF. **42** De Lory. **42-43** MF. **43** Joseph Stirling/
Click/Chicago. **44** all MF. **45** t Trevor Wood, b Linda Burgess. **46** Nadia
MacKenzie. **47** all Fritz von der Schulenberg. **48** Uli Butz. **49** t Robin
Laurance, b Gabe Palmer/IB. **50-51** Marc Romanelli/IB. **51** t John Sims,
b Melchior Digiacomo/IB. **52** t John Sims, b Angela Murphy. **53** t Pete
Turner/IB, cr Nick Carter, bl Trevor Wood. **54** Joseph Stirling/Click/
Chicago. **54-55** Chris Steele-Perkins/Magnum. **55** Bob Croxford. **56-57**
Peter Miller/IB. **58-59** Vautier/de Nanxe. **59** t John Sims, b Uli Butz.
60 t Vautier/de Nanxe, b Ashvin Gatha. **61** Laurie Lewis. **62** Robin
Laurance. **62-63** Richard Platt. **63** G. Boutin/Explorer. **64** t David Daye,
b Clive Boursnell. **64-65** Vautier/de Nanxe. **66** Jerry Young. **67** t Brigitte
et Jose Dupont/Explorer, b John Heseltine. **68** MF. **68-69** Francois
Dardets/IB. **69** Vautier/de Nanxe. **70** Janine Wiedel. **70-71** Sue Adler.
72 t Chris Steele-Perkins/Magnum, b Hans Wolf. **73** Dimitri Ilic/SGA.
74-75 Robin Laurance. **75** t Trevor Wood Picture Library, b David
Hiser/IB. **76-77** Frank Whitney/IB. **77** all MF. **78** t Janine Wiedel, b
Richard Platt. **79** Janin Wiedel. **80-81** Michael Boys/SGA. **82 and 83** All
De Lory. **84** Michael Boys/SGA. **85** all Laurie Lewis. **86** Michael
Boys/SGA. **87** l Michael Boys/SGA, r Ashvin Gatha. **88** all Brian Seed/
Click/Chicago. **89** Michael Boys/SGA. **90** all Laurie Lewis. **91** Michael
Boys/SGA. **92** All Laurie Lewis. **93** l Laurie Lewis, r Michael Boys/SGA.
94 Angela Murphy. **95** t Maggio/Kalish/IB, b Michael Boys/SGA. **96** John
Hedgecoe. **97** t Alain Choisnet/IB, b Sergio Dorantes. **98** t De Lory, b
Trevor Wood. **99** Sonia Halliday/Laura Lushington. **100** Michael
Boys/SGA. **101** t John Heseltine, b Timothy Beddow.

Additional commissioned photography by Michael Freeman, Laurie
Lewis, John Miller.

Acknowledgments Leeds Camera Centre, Nikon UK.

Artists Aziz Khan, Sandra Pond, Andrew Popkiewicz

Retouching Roy Flooks

Kodak, Ektachrome, Kodachrome and Kodacolor are trademarks

Time-Life Books Inc. offers a wide range of fine recordings, including a
Big Bands series. For subscription information, call 1-800-621-7026, or
write TIME-LIFE MUSIC, Time & Life Building, Chicago, Illinois 60611.

Notice: all readers should note that any production process mentioned
in this publication, particularly involving chemicals and chemical
processes, should be carried out strictly in accordance to the manufac-
turer's instructions.